IMAGES
of America
DECATUR

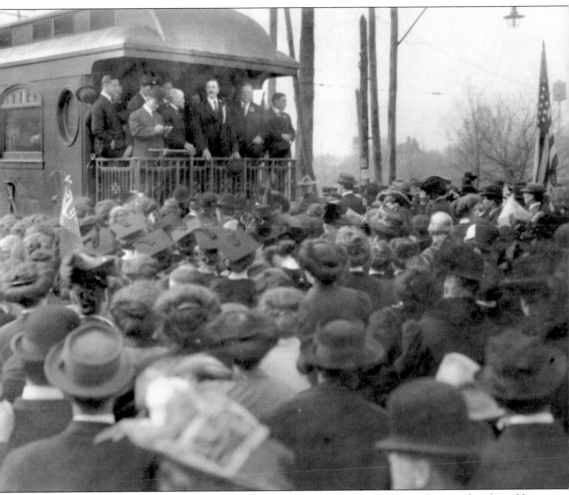

President-elect William Howard Taft visited Decatur by train and addressed a crowd gathered by the tracks in 1909. Taft, second from right in the group standing on the train, spoke to a crowd that included students from Agnes Scott College. The students can be seen standing together in a group toward the left center of the photograph, wearing mortarboards. Decatur mayor John Montgomery stands to the left of Taft. (Courtesy of DeKalb History Center.)

ON THE COVER: The Decatur High School baseball team stood for this team portrait in 1937. The team's coach, E. C. Culver, kneels in the first row at left (wearing a suit). Culver taught mathematics at the high school, which was known universally as Boys' High after 1932, which was when Girls' High opened. The two schools operated side by side. (Courtesy of City of Decatur Schools.)

IMAGES
of America

DECATUR

Joe Earle

ARCADIA
PUBLISHING

Published by Arcadia Publishing
Charleston, South Carolina

Printed in the United States of America

Library of Congress Control Number: 2010922853

For all general information contact Arcadia Publishing at:
Telephone 843-853-2070
Fax 843-853-0044
E-mail sales@arcadiapublishing.com
For customer service and orders:
Toll-Free 1-888-313-2665

Visit us on the Internet at www.arcadiapublishing.com

To Anne, Jay, and John

CONTENTS

ACKNOWLEDGMENTS

This book could not have come together without the photographs and historical information amassed through the years by the DeKalb History Center. I want to thank the center, executive director Melissa Forgey, and archivist Ben Zdencanovic for their patience and help in assembling this collection. I also wish to thank all the archivists who helped me locate images and all the people who contributed memories and photographs, especially Eddie Fowlkes, who records the history of Decatur High School's sports teams better than anyone I know.

 Most of all, I would like to thank the members of my family, who really made this project possible. My wife, Anne, knows this history better than I do and provided countless tidbits about the DeKalb County Courthouse and Mary Gay. My younger son, John, served as a research assistant and helped by finding and organizing story after story from the DeKalb History Center's files. My elder son, Jay, served as the IT department and made all the computer programs I did not understand do what they were supposed to. I am indebted deeply to them all.

Unless otherwise noted, images are courtesy of the DeKalb History Center.

INTRODUCTION

Decatur, Georgia, is a courthouse town. It has been from the start. The Georgia General Assembly carved DeKalb County from Henry County in 1822 and created Decatur in 1823 to serve as "the site of the public buildings for the county of DeKalb." The lawmakers placed the town of Decatur near the center of the new county and at the crossroads of two busy Native American trails, the Sandtown Trail and the Shallow Ford Trail (now known as Clairemont Avenue). In 1853, DeKalb County was divided, and the western portion became Fulton County, which means Decatur is now situated closer to the DeKalb-Fulton county line rather than the middle of the county.

The new town was named in honor of Commodore Stephen Decatur, a popular naval hero of the early 19th century who fought pirates, distinguished himself in the War of 1812, and died during a duel in 1820. A number of communities across the United States have been named to honor Commodore Decatur, including Decatur, Alabama, and Decatur, Illinois, but he probably now is best remembered for a single, jingoistic after-dinner toast: "Our country! In her intercourse with foreign nations, may she always be in the right, but our country right or wrong."

During its first few years, the little Georgia town was a rough-and-tumble place. The closest large market town was four days away by wagon, so nine or 10 local shops sprang up in Decatur. Only one of Decatur's new shopkeepers refused to stock liquor, according to Vivian Price's *History of DeKalb County, Georgia, 1820–1900*. This meant that pioneer residents could find plenty of outlets for corn whisky and peach and apple brandy. At night, "wild boys" tormented tipplers who were unable to properly find their way home. There were other troubles, too. A Decatur blacksmith had a portion of his ear bitten off in a fight; the perpetrator was sentenced to stand in the stocks, which were located at the jail. In fact, DeKalb lawmen made their first arrest before the jail was even finished. A man convicted of manslaughter in 1823 had to be jailed in Gwinnett County since "there was no safe jail in DeKalb," according to the court.

Meanwhile, religious folks started moving in. Residents began worship services in Decatur homes soon after the town was chartered. A Methodist church had been built by 1826, which is thought to be the first building in the city used solely for worship. The Georgia Legislature incorporated the Decatur Presbyterian Church the following year. A Baptist congregation, a splinter group from a nearby church, settled in the city in 1839 and was called Decatur Baptist Church, but that congregation moved out of town just two years later. Soon after religious groups began building churches, schools sprang up. Some operated from church buildings and others from the schoolmasters' homes. Decatur settled down to become a quiet country town centered on its courthouse square.

In its early years, Decatur attracted its share of interesting residents and institutions. In the 1850s, Thomas Holley Chivers, a poet and friend of Edgar Allan Poe, lived in a two-story house called Villa Allegra. Civil War memoirist Mary Gay, who wrote *Life in Dixie during the War* among other books, lived in a small frame house downtown. Rebecca Latimer Felton, the first woman to be seated in the U.S. Senate (if only for a day), lived briefly in Decatur so that she and her sisters could get a better education than the one available to them in rural schoolhouses.

During the Civil War, Decatur played host to a brief skirmish in the run-up to the Battle of Atlanta. Caroline McKinley Clarke wrote in *The Story of Decatur 1823–1899* that Confederate cavalry fought hand-to-hand with Union troops who had established trenches south of Decatur. The Confederates pushed the Union troops through the city to the town cemetery, Clarke wrote, but the Confederates quickly moved on. Still, Decatur felt the strain of the war. The Union army occupied the city, commandeering homes and provisions during and after the Battle of Atlanta. Mary Gay painted a bleak picture in the following excerpt from *Life in Dixie During the War*: "In vain did I look round for relief. There was nothing left in the country to eat. Yea, a crow flying over it would have failed to discover a morsel with which to appease its hunger . . . Every larder was empty, and those with tens of thousands of dollars were as poor as the poorest and as hungry, too."

Rebuilding began soon after the war. Mary Gay traveled to Kentucky and raised $600 for a building that would be the house of the First Baptist Church of Decatur, which had organized during the war in the fall of 1862. That amount matched the total the congregation had been able to raise in Decatur and pushed construction plans along. First Baptist opened its first building, called the "Little Red Brick Church," in 1871.

During the remainder of the century, Decatur's churches continued to expand. African American residents started to organize churches. Among some of these early churches were Antioch African Methodist Episcopal, which built a one-room church in 1874, and Thankful Baptist Church, which opened in 1882.

In addition to churches, charitable groups soon appeared in the small city. Dr. Jesse Boring, a Methodist minister, organized the United Methodist Children's Home to help the "huge numbers of abandoned and orphaned children wandering rootless and homeless about the countryside" after the war, according to Gerald Winkler, who wrote a history of the orphanage. Fire destroyed the original home in Norcross, so in 1873, the children's home was opened on 218 acres near Decatur.

In 1915, Scottish Rite Convalescent Home for Crippled Children opened with 18 beds in the southwestern portion of the city, which is now known as the Oakhurst neighborhood. Four years later, it was renamed Scottish Rite Hospital for Crippled Children, and the well-known Atlanta architect Neel Reid designed a new 50-bed institution. It continued operation in the area until 1976.

Schools also prospered. Private schools provided instruction in Decatur during the 19th century. Dr. John S. Wilson, who organized the Decatur Presbyterian Church, also established the Hannah Moore Institute for Girls. In 1889, the Donald Fraser School for Boys opened. In that same year, the Decatur Female Seminary admitted its first students. That first batch of students included a half dozen boys, but by its second year of operation, the school admitted only girls. The school was renamed the Agnes Scott Academy to honor the mother of one of its early patrons, and later the name was changed to the Agnes Scott Institute. In 1906, the school awarded its first bachelor's degree as Agnes Scott College.

Decatur's public schools did not get started until the 20th century. The first public school classes for white children were taught in 1902 in a wood-framed schoolhouse. It housed the public school until the Central Grammar School opened seven years later, in 1909. African American children were taught in a Presbyterian church until the opening of Herring Street School in 1913. In the century since Central Grammar opened, Decatur residents have watched the little school system expand and attract new generations of parents and students. Many residents now list Decatur's schools among their city's best bragging points, along with the churches and housing.

These days, Decatur simply, and proudly, declares itself "a city of homes, schools, and places of worship."

One

THE TRAIN
AND THE TOWN

Some residents of the city of Decatur like to say that without a touch of snobbery on the part of their forebears, the city of Atlanta might never have come into existence.

It is believed that when the railroads first pushed into north Georgia in the early 1800s, folks in Decatur told them to take their noisy, smelly engines somewhere else. So the new Georgia Railroad built its turnaround in a neighboring community at the end of the line, which was called Terminus. This town quickly grew to become the bustling big city of Atlanta while Decatur proudly remained a small town caught in Atlanta's orbit. This often-repeated tale is almost surely false. The train did come to Decatur in 1845; however, it steamed its way past the little town and headed straight to what had been its real destination all along, the crossroads that would become Atlanta.

Still, Decatur was a thriving community more than a decade before its bigger and better-known neighbor. The railroad story still resonates with many Decatur residents, because it fits the way they see their town: independent, opinionated, and certainly not a part of the city of Atlanta.

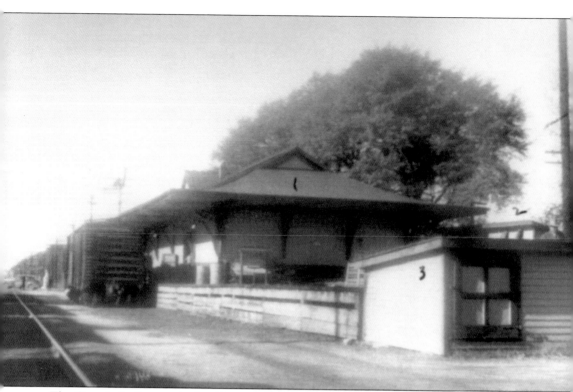

The Georgia Railway arrived in Decatur in 1845. Although some still say the train was pushed out of town because residents objected to the smoke and noise, it is more likely the train bypassed the little town in order to build its tracks on high ground just south of the city. Union troops destroyed the original railroad depot in 1864. The Decatur depot depicted here probably was built around 1890. It was remodeled several times before this photograph was taken around 1935. The numbers on the photograph mark the depot (1), the supervisor's storeroom (2), and the mail storage area (3).

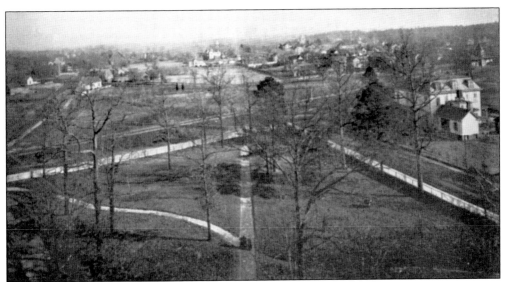

This view shows Decatur in the mid- to late 1890s. The photograph was taken looking north from the tower at Agnes Scott Institute, later renamed Agnes Scott College. At the right of the image stands the White House, the first home of the school. The DeKalb County Courthouse and the courthouse square appear toward the center of the image, past the railroad tracks. Small homes appear on streets around the square.

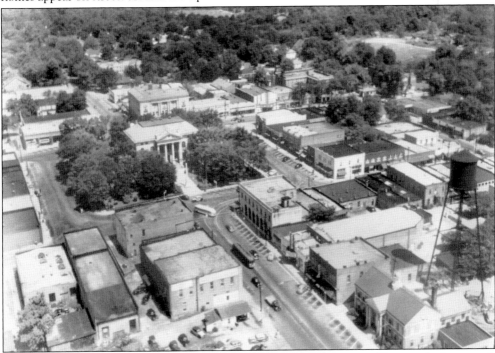

This aerial photograph, taken in the 1930s or 1940s, offers another view of Decatur looking north and shows how dramatically the small city changed during the first half of the 20th century. The DeKalb County Courthouse still stands at the center of the town, but extensive commercial development has sprung up around the courthouse square. At the time, the streets around the courthouse did, in fact, make a square.

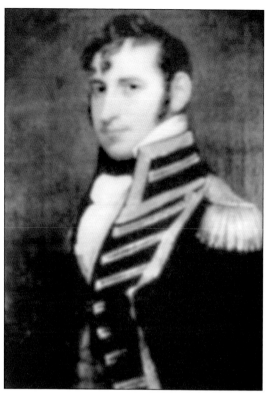

The city of Decatur was named for Commodore Stephen Decatur, a popular naval hero of the early 19th century. Commodore Decatur fought pirates, distinguished himself in the War of 1812, and died in a duel with another naval officer, Commodore James Barron, in 1820. Despite his fame in the early 19th century, Commodore Decatur probably now is best remembered for saying "Our country! In her intercourse with foreign nations, may she always be in the right, but our country right or wrong." (Portrait from wikipedia.org.)

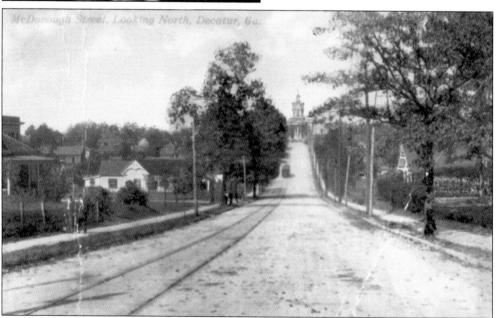

Decatur was created to be the seat of DeKalb County's government. In legislation founding Decatur in 1823, the Georgia General Assembly (then sitting in Milledgeville) said "the site of the public buildings for the county of DeKalb . . . Shall be called and known by the name of Decatur." In the years since, the DeKalb County Courthouse has stood at the center of the town. It is shown here in a view looking up McDonough Street.

DeKalb County initially was settled by small farmers, many having immigrated from the Carolinas and Virginia. DeKalb remained a farming community throughout the 19th century and much of the 20th century. Agricultural businesses and open land surrounded Decatur, as shown in these early 1920s views. The above photograph is looking south on Avery Street. The Decatur Floral Company's greenhouses can be seen on Kirk Road (below). The Decatur Floral Company opened in 1912 as the Atlanta Floral Company, but its name was changed in 1922 to represent its hometown. By the time the business closed in the mid-1980s, Decatur was engulfed in the suburban sprawl surrounding Atlanta. The greenhouses were replaced by houses.

Schools opened in Decatur soon after settlers came to the area. In the 19th century, education was handled by private schools, such as the Hannah Moore Collegiate Institute, which attracted Rebecca Latimer Felton's family to town. Decatur's public school system started in 1902. In 1913, the system built Glennwood School, which is shown here in a panoramic photograph. At that

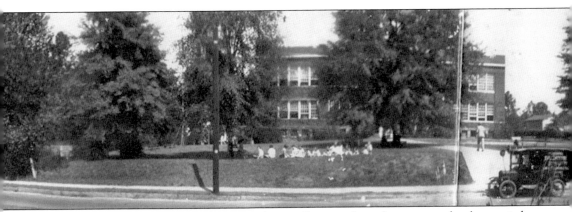

time, high school students took classes on the top floor, and an elementary school occupied the first floor and basement. Also in 1913, the school system built Herring Street School as an elementary and high school for African American students.

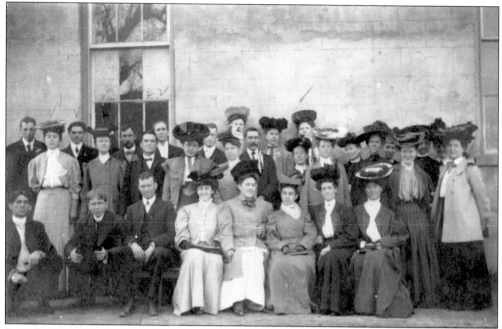

DeKalb County's school teachers posed for this group portrait on March 10, 1906. The city of Decatur had started its public school system just four years earlier. Public school classes were held in a small wooden building at the intersection of Candler Street and Ponce de Leon Avenue until Central Grammar School was opened in 1909.

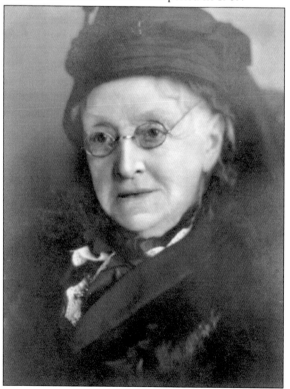

Rebecca Latimer Felton, who lived in Decatur while she attended school, was a writer and suffragette. In 1922, when Senator Tom Watson died, the governor appointed Felton to take his seat in the U.S. Senate. The appointment was intended to curry favor with women who had just won the vote. Felton's appointment was supposed to be honorary—her replacement was elected before the Senate convened and Felton could take the seat. But senator-elect Walter F. George delayed his arrival at the Senate, allowing Felton to be sworn in and serve for a day. She became the first woman to take a seat in the Senate and, at age 87, the oldest freshman senator.

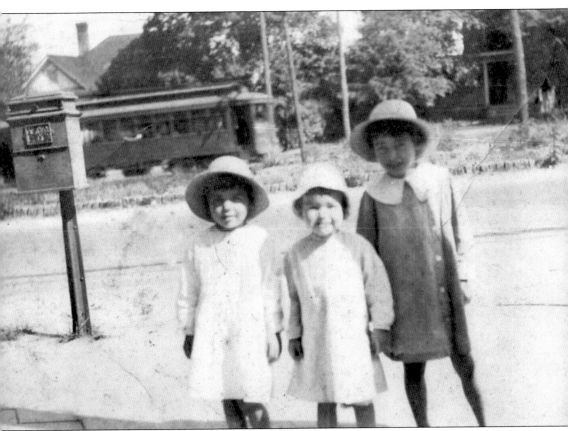

From left to right, Lib Frierson, age six; brother Bill, age five; and older sister Alice, age eight, gather at the end of Adams Street, which was where they lived when this photograph was taken in the early 1920s. Behind them is the electric streetcar their mother, Alice Frierson, rode in her daily commute to work at a bank in downtown Atlanta. (Courtesy of Lib Frierson Kennedy.)

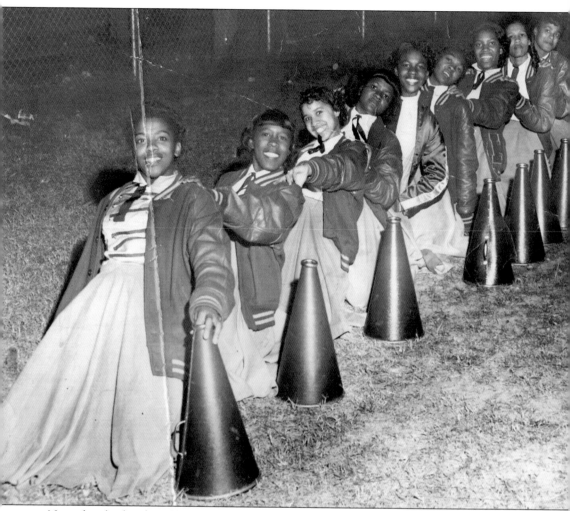

Nine cheerleaders from Herring Street High School put down their megaphones to strike a pose for this group portrait in the early 1950s, probably 1952. Decatur's city school system opened the Herring Street School in 1913. It housed the elementary and high schools for Decatur's African American children. It remained in use until 1956. (Courtesy of Sharon Johnson Skrine.)

Two

HOMES

In 1907, John Mason and Polemon Weekes purchased a block of farmland west of Agnes Scott College with plans to build houses on it. A sheep farmer named Adams owned the land, recalled Lib Kennedy, who grew up in the area. Architect Leila Ross Wilburn, who was one of the first women architects in Georgia and Kennedy's aunt, agreed to design homes to be built in the neighborhood. The houses rose one by one. "As they built one, she'd give them the plans for the next one," Kennedy said.

The neighborhood now is known as the MAK Historic District. It takes its name from the three streets that run through it—McDonough and Adams Streets and Kings Highway. Kennedy, who lived on Adams Street, remembers when large houses lined those streets and her mother, Alice Frierson, commuted to a job in downtown Atlanta.

Houses have long been among Decatur's chief attractions. In the 1800s, merchants and business owners erected fine homes near the city square. Later, after Mason and Weekes showed the way, developers began building homes that would attract families headed by commuters who traveled to work in Atlanta.

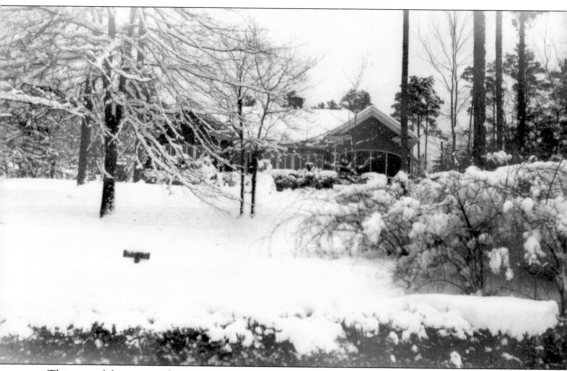

This graceful portrait of snow covering the Murphey home on Ponce de Leon Avenue was taken in the 1930s. At the time, the house was one of only three homes that were located between Scott Boulevard and Ponce de Leon Elementary School, which stood near the creek at the bottom of the hill. (Courtesy of Pat Murphey.)

Poet Thomas Holley Chivers settled in Decatur in 1856 and called his two-story frame home in South Decatur the Villa Allegra. He lived there only two years before his death in 1858 at age 52. He is buried in the Decatur Cemetery. His son Thomas H. Chivers Jr. served as a marshal and as sexton of the cemetery, according to Vivian Price's *History of DeKalb County*.

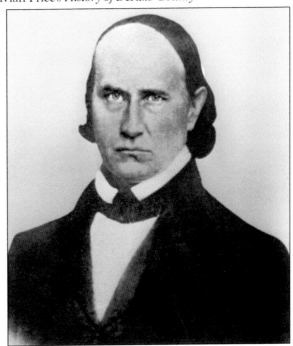

The son of a wealthy Wilkes County planter, Thomas Holley Chivers was trained as a doctor and was an inventor and painter. However, he is now remembered for his poetry and for his association with poet Edgar Allan Poe. The two corresponded, but after Poe's death, Chivers claimed Poe had patterned poems, including "The Raven," on Chivers's work. Others say it was obvious that Poe influenced Chivers and not the other way round.

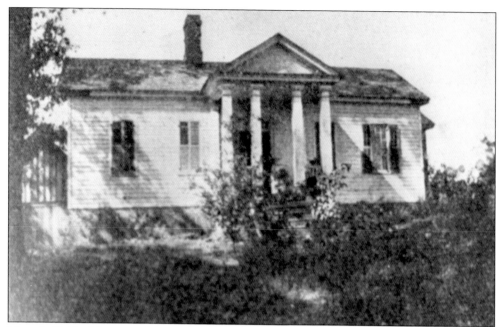

Mary A. H. Gay's house on Marshall Street in downtown Decatur was built in the 1820s, making it one of the oldest houses in DeKalb County. In the 1970s, the house was moved to Trinity Place. During the Civil War, the Union army took over the house during the occupation of Decatur in 1864. Gen. Kenner Garrard used Gay's house as his headquarters, and troops camped in the yard. Gay and her mother continued to live in the house while Garrard occupied it. (Courtesy of Georgia State Archives, Vanishing Georgia Collection.)

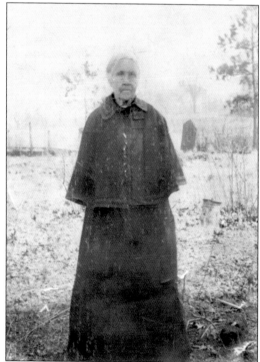

Author Mary A. H. Gay wrote of her experiences in Decatur during the Civil War in *Life in Dixie during the War*. After the war, she traveled the South, raising $600 in small donations to help build the First Baptist Church of Decatur's first building. Gay was a charter member of Decatur's chapter of the United Daughters of the Confederacy. She and her sister, Missouri, were active in the Women's Christian Temperance Union. In her later years, she was described as a tiny woman who always wore black.

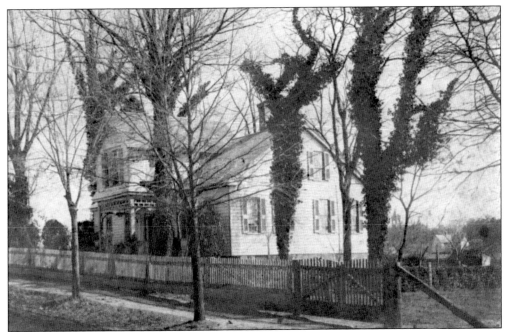

The Swanton House is believed to have been built shortly after the founding of the city of Decatur. Benjamin Swanton, who made his money during the Dahlonega gold rush, purchased the home on what was then Atlanta Avenue (now Swanton Way) around 1850. In the 1970s, it was moved to Trinity Place, where it now stands next to the Mary Gay House.

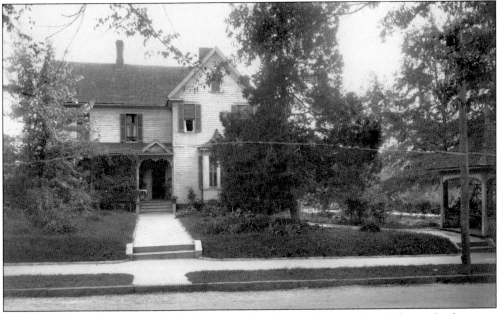

High House, located on Sycamore, supposedly earned its nickname either by being the first two-story home in Decatur or because of its location on a slight rise, or both. The house is said to have been built in 1830, and the well at the house became a local landmark. An often-told story had it that Gen. William T. Sherman himself watered his horse at the well. Later couples would court on the benches around the well, which were shaded by the well house roof.

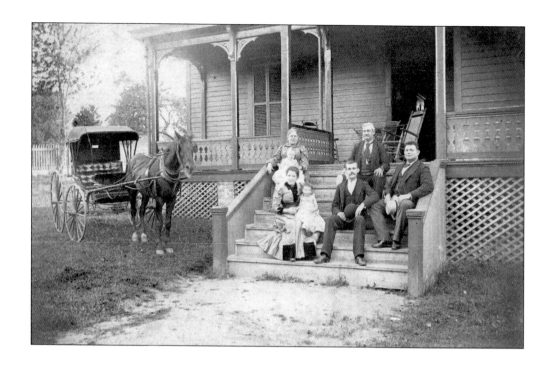

The Ramspeck House was located on the corner of Broad Street (now known as East Ponce de Leon Avenue) and Church Street, which was later the site of the Hotel Candler. George A. Ramspeck, a German immigrant, and his son, Theodore R. Ramspeck, were prominent Decatur merchants. T. R. Ramspeck's son, Robert, served in the U.S. House of Representatives from 1929 to 1945 and was House Majority Whip from 1941 to 1945.

Nat White (right), his son, and wife are shown in front of their log cabin in this family portrait. The wood shingle–roofed cabin was built in the deep woods near what is now Scott Boulevard in north Decatur. Water came from a nearby spring. (Courtesy of Georgia State Archives, Vanishing Georgia Collection.)

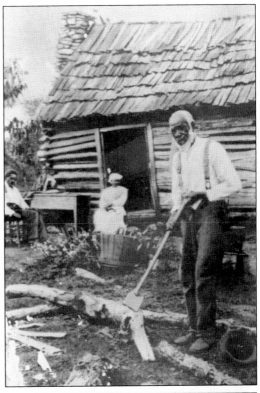

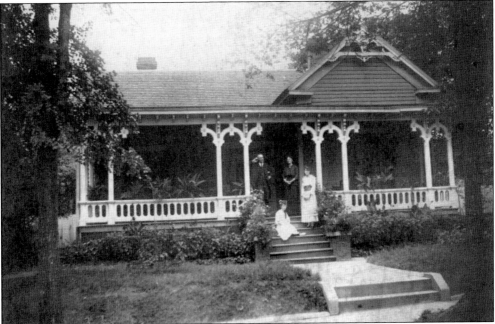

John Montgomery and his family occupied this home on Sycamore Street, where they were photographed in 1914. Mary Powell Montgomery, who was John's wife, lived to age 94 and spent most of her life on Sycamore Street. The four family members gathered on the steps are identified on the back of the photograph simply as "Mama, Papa, Mary, and Caroline."

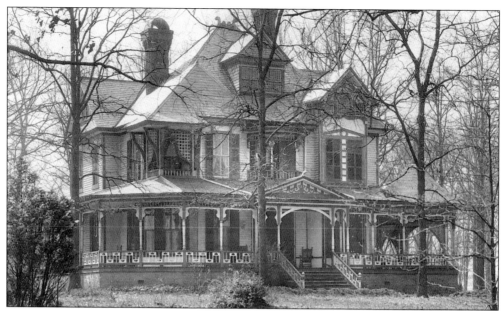

Joseph A. Sams built his home on College Avenue around 1890 in an area called Sams Crossing, which was named for members of his family. J. A. Sams worked for the railroad. He used to travel to and from work on the train that stopped at Sams Crossing to pick up passengers for Atlanta. A small wooden railway station that was located in the area burned in 1905. Today a short street named Sams Crossing intersects the railroad tracks in the area between Decatur and Avondale Estates.

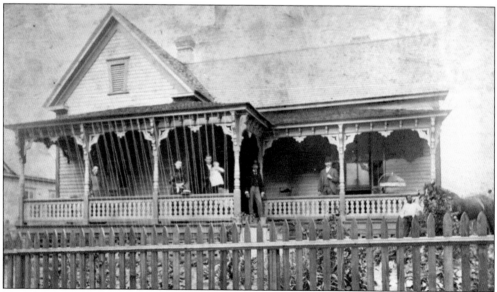

Hamilton Weekes and his family were photographed in 1892 on the porch of Weekes's home on Church Street. Hamilton Weekes, holding the baby, Lois, stands with his wife, Leona, at center. The two men to the right in the photograph are identified as his brothers, Polemon and Charles Weekes. The woman on the far left in the photograph is Leona Weekes's mother, Mrs. Fowler. The Weekes brothers operated a shop on Decatur's square. (Courtesy of the Georgia State Archives, Vanishing Georgia Collection.)

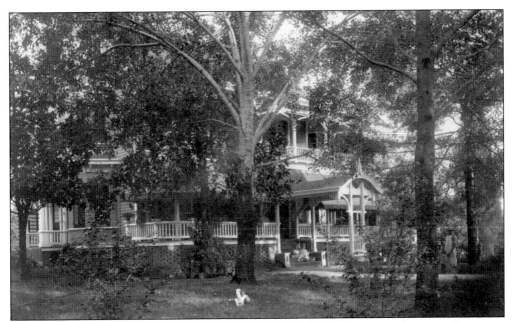

Decatur businessman George Washington Scott lived in this 1830s-vintage house on Sycamore. Scott moved his family to Decatur from the coast to avoid a yellow fever epidemic and bought this home in 1877. He later added a turret to the front to hold a water tank. Scott became a major benefactor of the school that would become Agnes Scott College. The school was named for his mother, Agnes Irvine Scott. (Photograph copyright, Agnes Scott College, used by permission.)

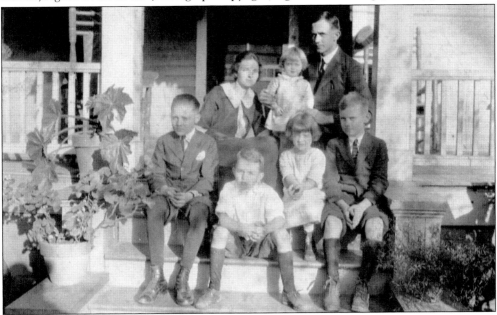

In the early 1920s, members of the Everitt family take in a breath of fresh air in this family portrait on the porch of their home on Barry Street. From left to right are (first row) Olin Everitt, Edwin Everitt, Doris Everitt, and Floyd Everitt; (second row) Leona Hill Everitt, Edna Mae Everitt, and George Edward Everitt. Olin and Floyd were George and Leona's nephews. The others were their children. (Courtesy of the Georgia State Archives, Vanishing Georgia Collection.)

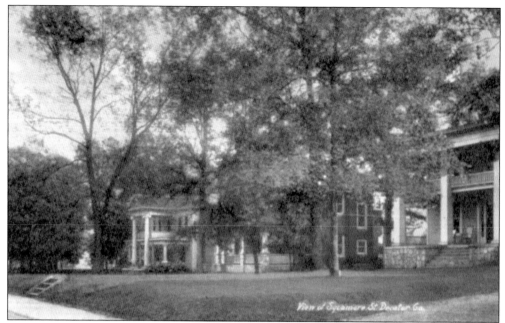

Fine homes lined Sycamore Street. Local legend has it that the Reverend Marion Washington Sams of Decatur Baptist Church, who lived at Sams Crossing, suggested Sycamore be named for the trees that grew alongside the road as it came into downtown Decatur.

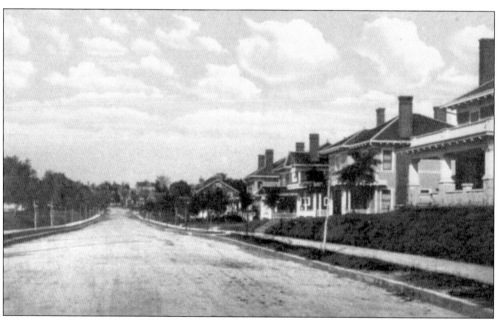

Adams Street, located near Agnes Scott College, was part of the first residential subdivision developed in Decatur. Adams took its name from the farmer whose property had been purchased for the development. One of Georgia's first women architects, Leila Ross Wilburn designed many of the houses originally built on the street. The area around Adams and McDonough Streets and Kings Highway is known as the MAK district and was Decatur's first designated historic district.

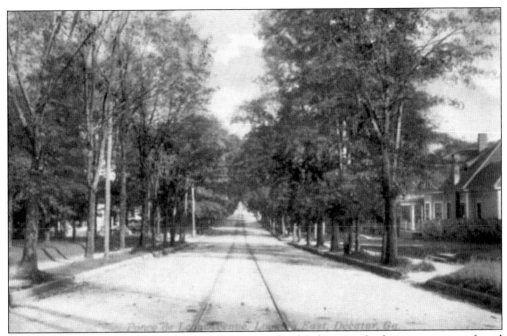

The expansion of streetcar lines boosted the growth of Atlanta's suburbs as commuters found they could work in the city and still head home to Decatur or to communities even farther from downtown Atlanta. A trolley ran on rails laid down the center of tree-lined Ponce de Leon Avenue as it headed east in Decatur.

Decatur land prices have risen a bit since the first decade of the 20th century. This advertisement offered 21 lots for sale to potential home buyers in neighborhoods south of Agnes Scott College. In their advertising, developers carefully noted the location of Decatur's trolley line. The trolleys may be gone, but it seems that some things never change. Even then, developers promised Decatur houses were "bound to enhance in value."

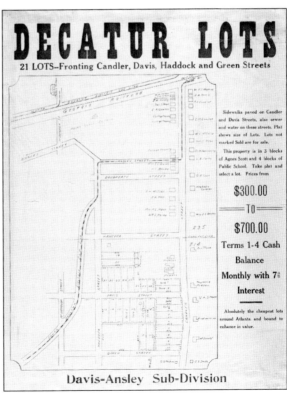

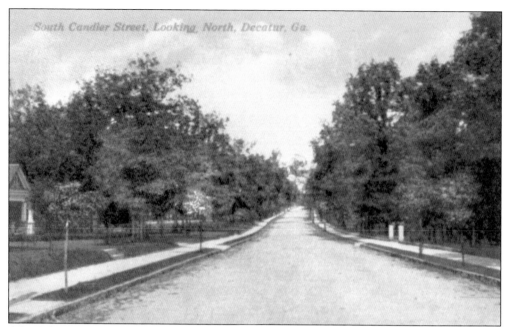

After John Mason and Polemon Weekes developed the area west of Agnes Scott College, other areas of the city began to attract new developments that offered homes for commuters. Tree-shaded homes lined this portion of South Candler Street south of Agnes Scott College.

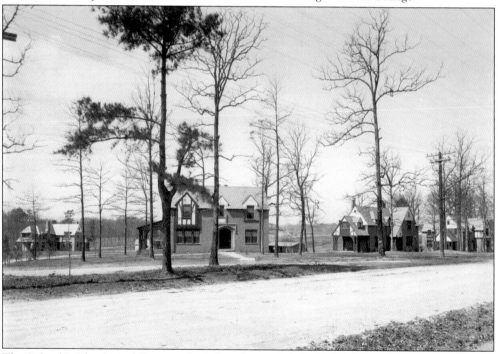

The Columbia Theological Seminary built these homes to house faculty members after the seminary moved to Decatur from Columbia, South Carolina, in the late 1920s. The homes, designed to match the architectural style of the buildings on the seminary campus, still stand on Columbia Drive. (Courtesy of Columbia Theological Seminary archives.)

When Gene Slack Morse's parents, Searcy and Julia Pratt Slack, moved to Decatur in the early 1920s, they bought this house at 636 Sycamore Street. Searcy Slack worked as a bridge engineer with the state highway department at the time. (Courtesy of Gene Slack Morse.)

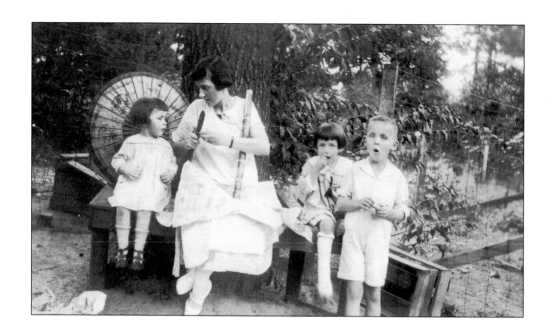

In the above photograph, Julia Slack and her children play in the wooded backyard of the Slacks' home on Clairemont Avenue, which was the second home the family occupied in Decatur. Searcy Slack Jr., known as Bud, was the eldest. His sister Ruth was born next, and Gene, who was born on Bud's third birthday, was the third child. The youngest of the four was Julia. Note the tire swing and the chickens that appear in the photograph below. (Both, courtesy of Gene Slack Morse.)

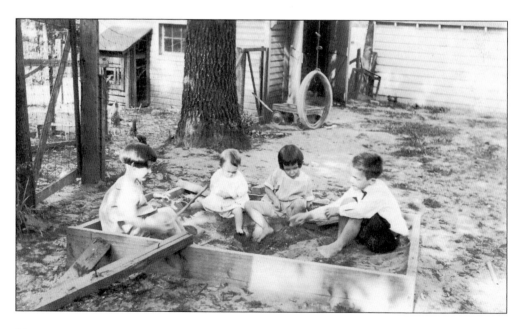

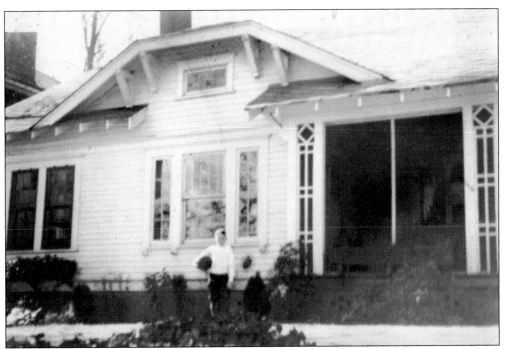

After Alice Frierson's husband died of influenza in 1918, she and her young children returned to Decatur from the town in South Carolina where they had been living. Alice Frierson had a small house built near her mother's home on Adams Street. The small house, shown above, was built on a parcel at 115 Adams Street that had been the rear garden on a large lot occupied by a home that faced College Street. Once her children were enrolled in school, Frierson found a job working at a bank in downtown Atlanta. (Both, courtesy of Lib Kennedy.)

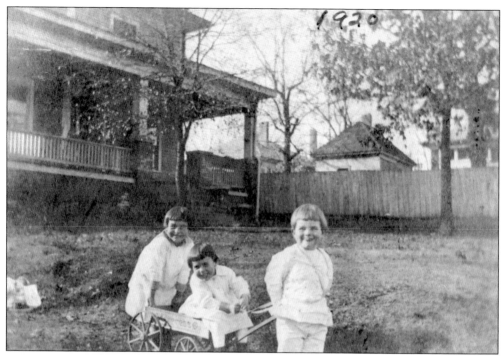

1920

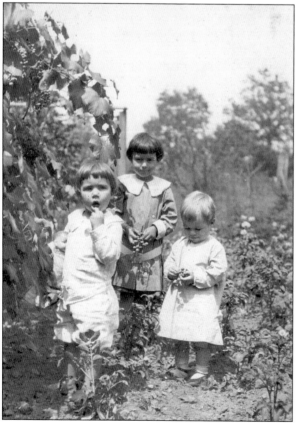

In these photographs, taken in the early 1920s, the three Frierson children, Lib, Alice, and Bill, play at houses on Adams Street. Lib Frierson Kennedy recalls when large two-story homes lined Adams Street and other streets nearby. Many were designed by their "Aunt Lee," architect Leila Ross Wilburn. Wilburn opened her own firm in 1909. Kennedy says the grape arbor was probably at her grandmother's house, which was down the street from the small house her mother had built in 1915 on Adams Street. (Both, courtesy of Lib Kennedy.)

Pat Murphey models his tuxedo outside his family's home on Ponce de Leon Avenue. Murphey, who was seven or eight at the time, wore the tux when he appeared on stage during a theatrical production at Ponce de Leon Elementary School. In the 1930s, when Murphey was in elementary school, student theatrical performances were regular events. Students performed one or two plays a year in front of an audience composed primarily of their parents. (Courtesy of Pat Murphey.)

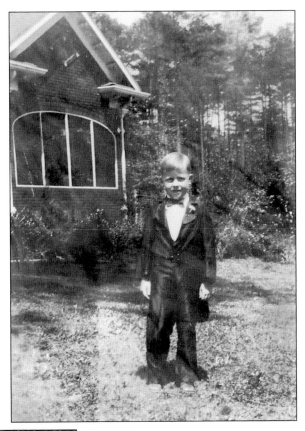

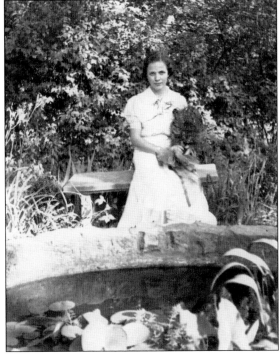

Gene Slack relaxes on a bench by a pond her father, Searcy Slack, built at their home at 455 Clairemont Avenue in this photograph, taken in the 1930s. Her father originally intended the pond to be a swimming pool for the children, she said, but it quickly became a water garden filled with plants. So Gene did her swimming at a private pool that was open to the public and located a few blocks away on Church Street. (Courtesy of Gene Slack Morse.)

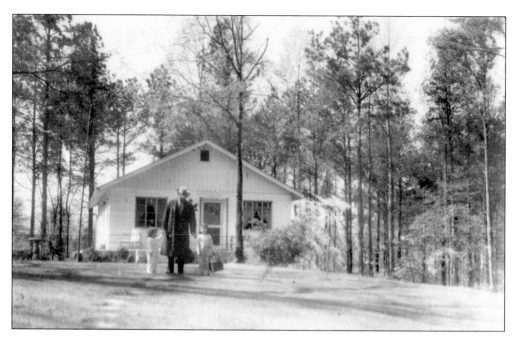

Gene Slack Morse's children join their grandfather for a jaunt through the yard at the Morses' first home on Scott Boulevard. Gene and her husband, Chester, moved into the small house, shown above, in 1946 and lived there for about five years. During those years, they purchased the adjacent property and built a larger house, pictured below. The Morses' children have donated the property to the Decatur Preservation Alliance, a nonprofit foundation, so the property and its native plants can eventually become a public garden. (Both, courtesy of Gene Slack Morse.)

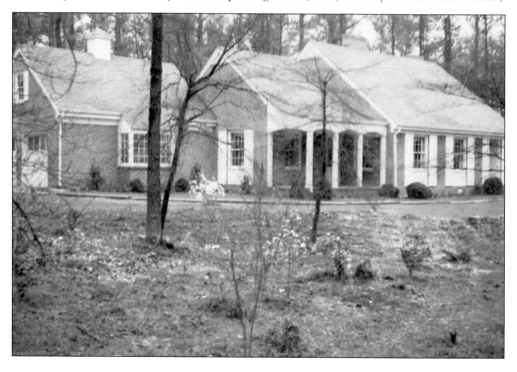

Three

SCHOOLS

Decatur's city school system sets the town apart from other communities. Decatur's first schools sprang up soon after the town was settled. Classes met in homes or in church buildings. After 1889, students attended one of two private schools, the Donald Fraser School for Boys or the Agnes Scott Academy for Girls, which later became Agnes Scott College.

The Fraser school—the name is spelled "Frazer" in some sources—was organized in 1892 and was operated in the brick building that had housed the Decatur Presbyterian Church. "The Donald Fraser High School is a college preparatory school, and its course of study is mapped out with special reference to the college," the school said in printed material from around 1902. "Those students who successfully complete our curriculum will be prepared for honorable competition in any college of the South or East. A number of leading colleges accept our graduates on certificate, without examination."

The first public school classes were taught in 1902 in a small wood-frame building. The first schoolhouse built by the public school system was Central Grammar School, which opened in 1909. Later the building housed Decatur Girls' High. Boys' High stood next door. A fence kept them apart.

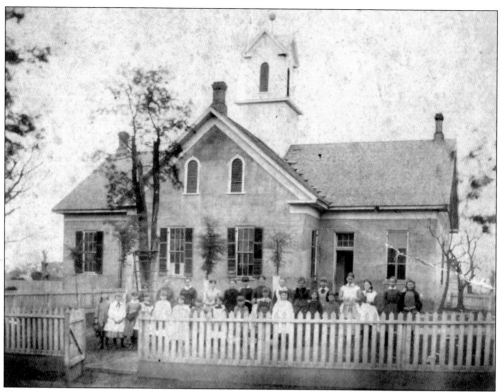

Shown in the above photograph, the Female Academy was one of several Decatur schools that offered instruction to young girls during the 19th century. In her Decatur history, Caroline McKinney Clarke offers no date for this photograph, but identifies a girl in the second row, eighth from right, as Mary Powell, who was awarded a gold medal for superior scholarship in 1879. In the photograph below, Harriett Milledge's first grade class gathered for this group portrait in 1895.

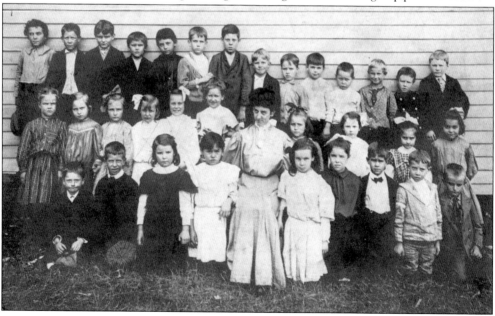

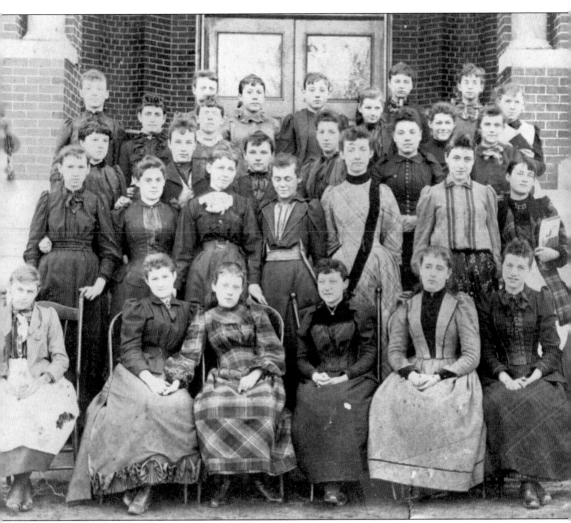

The women and girls in this photograph are identified as among the first classes to attend the Agnes Scott Institute. The school was formed in 1890 as a girls' school and took its name from the mother of one of its early benefactors, George Washington Scott. The photograph supposedly was taken some time after 1892. In 1904–1905, Agnes Scott Academy and Agnes Scott College split into separate institutions. The academy operated as a high school for girls until about 1912.

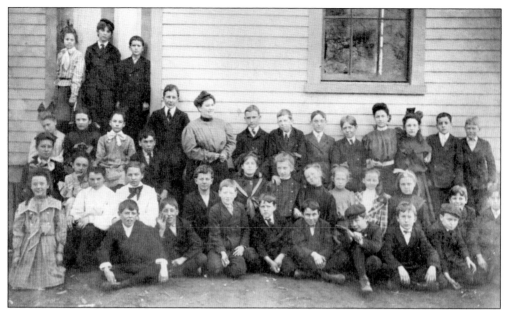

When Decatur's public school system opened in 1902, it offered classes only through eighth grade. These photographs show Decatur's fifth and sixth graders (above) and the seventh graders (below) in 1906. Their school was located on the corner of Broad Street (now Ponce de Leon Avenue) and Candler Street. Annie Jones taught the fifth and sixth graders. E. E. Treadwell, the Decatur school system's first superintendent, poses in the photograph below with the seventh graders. Treadwell (second row, second from right) headed the city school system until 1919. While he was superintendent, the district built the "south building," or Central Grammar School, which was used for classes for white students. The south building was later known as Decatur High School and Girls' High. The Herring Street School housed classes for African American students.

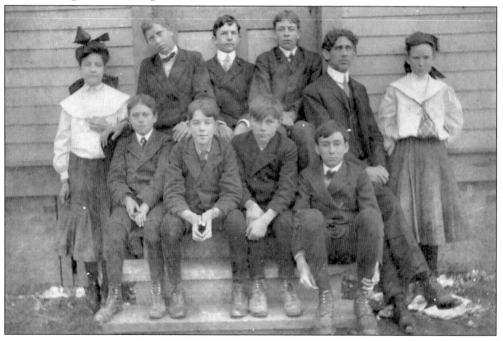

Decatur's city schools opened Central Grammar School in 1909. The structure became known simply as the "south building" in order to set it apart from the "north building," which was constructed in 1919. The south building housed many different schools through the years, including Decatur High School and Decatur Girls' High. Sixth and seventh graders pose with their teacher, Bessie Jones, in this photograph from 1910 or 1911.

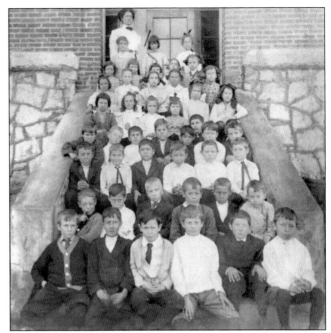

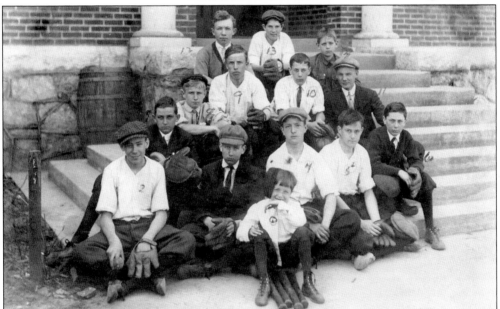

Although Central Grammar School opened in 1909 to teach first through eighth graders, the city of Decatur still had no public high school. Decatur students who wanted to go to college had to continue their studies in private schools. The Donald Fraser School closed its boarding department in 1909, but both the Agnes Scott Academy for Girls and the Donald Fraser High School for Boys continued to offer college preparatory courses for a few more years. In 1912, the first group to attend a public high school in Decatur took classes in the old Donald Fraser school building. The next year, the students moved to the new Glennwood School, which housed high school classes in its upper floor. This group of Decatur high school students was photographed in 1913 and included boys nicknamed "Pink," "Tub," "Fish," and "It."

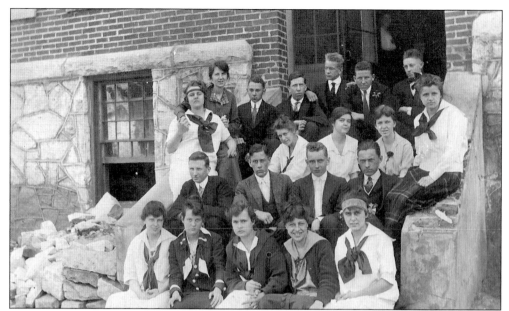

Members of the class of 1916, the first class to graduate from Decatur High School, gather for a class portrait on the school steps. On the back of the photograph, someone identified this group as "The Wild Twenty." They were identified as Margery Moore, Mary Will Montgomery, M. Stephenson, Josephine Tess, Thelma Hopkins, Martin Maddox, Lewis Estes, Wilfred Moore, Kenneth Cooper, Frances Simpson, Emma Hunt, Emily Walkins, Cynthia Pace, Margaret Boyce, Dorothy Smith, George Harold, George Brown, Marion Gartner, Warren Maddox, and Joe Harrell.

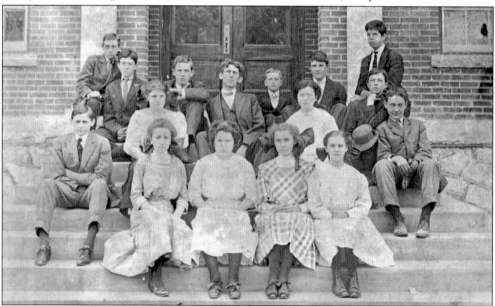

This photograph depicts one of the first classes to graduate from Decatur High School, according to Caroline McKinney Clarke's history of Decatur. The public school system offered only eight grades until 1912, when a high school opened in what had been the private Donald Fraser High School's building. In 1913, the Glennwood School, which housed classes for white students, and the Herring Street School, which housed classes for African American students, were built.

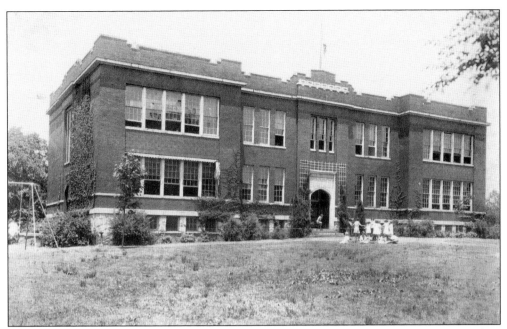

Glennwood Elementary, shown above as it looked in 1914, was the second school building constructed by the public school system. It was built in 1913 on the Glenn property "near where the car line makes its return loop," a contemporary newspaper account reported. It initially housed both elementary and high school classes. "The location of the high school on the extreme edge of Decatur may work a hardship on such children as live in distant parts of the town, but a suitable location near the center of town was hard to find," the *DeKalb New Era* reported. Apparently, children were able to make it to school. Below, Lucille Miller poses with her elementary school students in 1921. (Above, courtesy of City Schools of Decatur.)

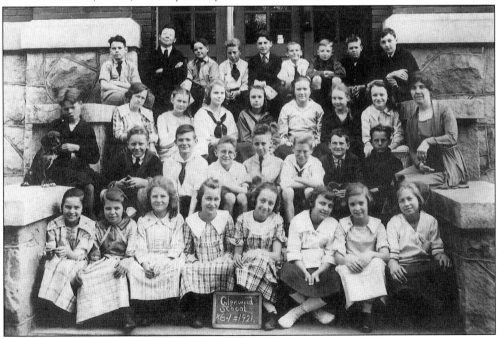

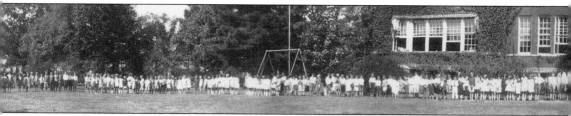

Students line up outside Glennwood Elementary. Glennwood, established in 1913, was built on the Glenn farm. Decatur High School's classes were taught in the upper floor at Glennwood from 1913 until about 1916, when high school classes were relocated to the old Central Grammar School building. Plans for the new school won attention. A Bartow County newspaper (quoted by a DeKalb newspaper) wrote about plans to build the school and described it this way: "The

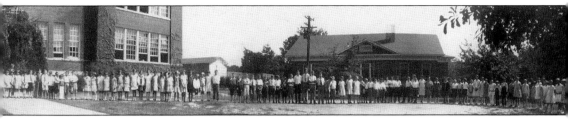

structure to be erected by Decatur will be one of the best equipped and most hygienic in the state and will have in it all modern improvements and equipment suited for school buildings." A local newspaper later noted the building "has been equipped with the latest and best steel desks, and the high school has been given a science room with a complete physical and chemical laboratory."

The Herring Street School, the first public school in the Decatur system for African Americans, opened in 1913. It held classes for all the African American students in the segregated district. A branch of the Decatur-DeKalb library (pictured below) was located on the campus of the Herring Street School. Beacon Elementary School and Trinity High School replaced Herring in 1956 and continued until 1966. The system was fully desegregated under court order in 1972.

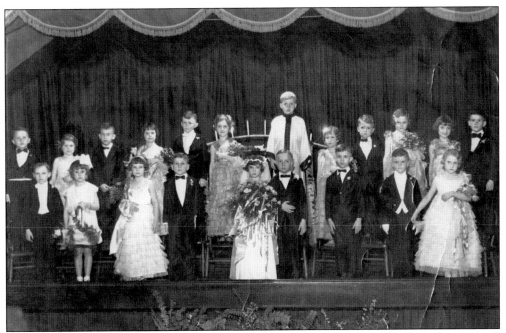

Ponce de Leon Elementary students assemble for a production of *Tom Thumb Wedding*, which they staged for their parents. Pat Murphey, at rear center, performed the part of the minister. In the 1920s, when this photograph was taken, Decatur's elementary schools regularly provided theatrical performances. (Courtesy of Pat Murphey.)

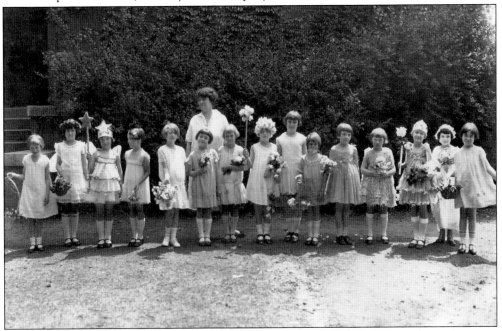

Girls in the second grade at Glennwood Elementary School dress in frilly finery and carry bouquets and wands to celebrate May Day in this photograph, taken in 1927 or 1928. Gene Slack Morse remembers that she and her fellow Glennwood students danced around a May pole to celebrate the arrival of the warm months. (Courtesy of Gene Slack Morse.)

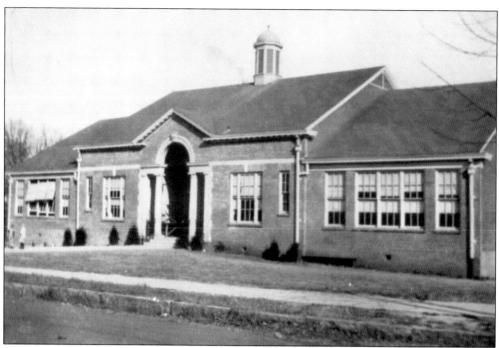

In the 1920s, Decatur grew by attracting commuters who could ride the streetcar lines to Atlanta. More families meant the schools quickly expanded and the public school district added two new schools, Winnona Park Elementary School (above) and Ponce de Leon Elementary School (below) in 1923. The Winnona Park building continues to be used as an elementary school. The Ponce de Leon building was razed in 1965. (Below, courtesy of City Schools of Decatur.)

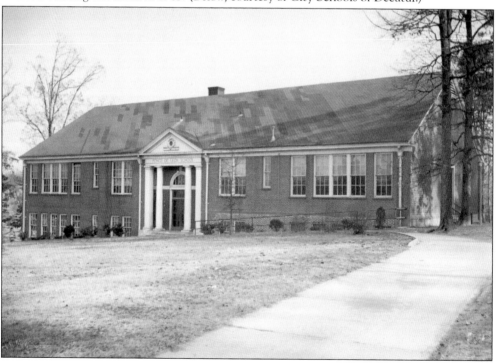

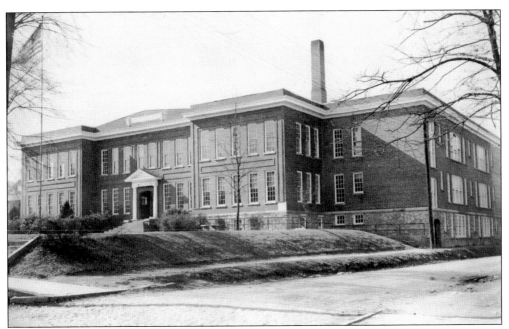

Decatur High School was coeducational from its start in 1912 until 1932, when it was divided into separate institutions for girls and boys, which were known simply as Girls' High (pictured above) and Boys' High (shown below). The two schools stood side by side on McDonough Street in the location where Decatur High School now stands. Girls' High operated in the south building, which had been constructed in 1909 to house Central Grammar School. Next door, Boys' High operated in the north building. The schools reunited in 1952 to become coeducational once again. (Both, courtesy of City Schools of Decatur.)

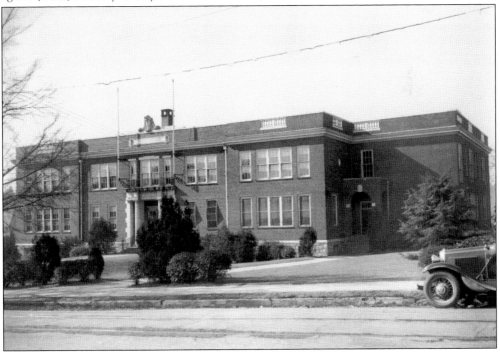

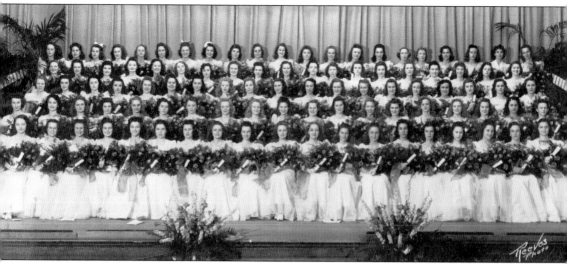

The girls of Decatur Girls' High School hold celebratory bouquets of flowers in this group portrait from 1941. For two decades, starting in 1932, Girls' High operated separately from Boys' High. The two schools stood side by side, but students were supposed to stay on their own side of what the school district has called an infamous fence, which separated them.

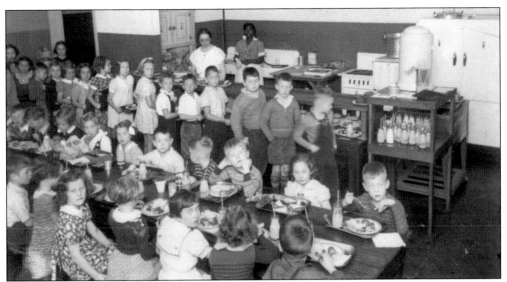

Students at Clairemont Elementary School line up for lunch in this 1941 photograph. Mrs. E. E. Treadwell, the wife of the Decatur school superintendent, ran Clairemont's cafeteria from 1937 until the 1960s. Clairemont opened in 1936. It was the only new school built by the district in the 1930s. Another wave of new school buildings opened in the 1950s. College Heights Elementary and Westchester Elementary opened in 1955, and Beacon Elementary and Trinity High School opened in 1956.

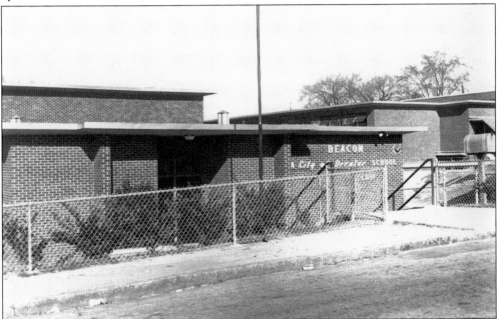

Two new school buildings were constructed in 1956 to house classrooms for African American students. Beacon Elementary and Trinity High School were built near the location of the old Herring Street School building. Trinity High fronted Trinity Street, which had been called Herring Street before it was renamed. The system started slowly desegregating its classes in 1965. Trinity High officially closed in 1967, and students were transferred to Decatur High School. In 1972, the schools received a court order to completely desegregate.

Members of Herring Street School's homecoming court were captured in this photograph, taken at the Decatur stadium in the early 1950s. In the 1940s and 1950s, both Herring Street and Decatur High used the field, which was located between the two schools. During football season, Decatur High played its games on Fridays and Herring on Saturdays. In 1930, Decatur installed lights, allowing games to be played at night, creating the first lit field in metro Atlanta, according to the public school system. (Courtesy of Sharon Skrine.)

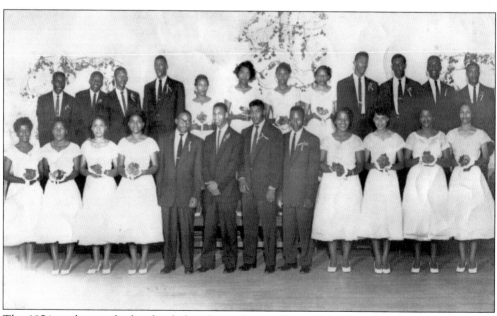

The 1954 graduating high school class from Herring Street School included sisters Mary Kate Williams (first row, far left) and Ruby Nell Williams (first row, second from right). The high school, which served African American students in Decatur's segregated school system, closed in 1956 when Trinity High School opened. (Courtesy of Sharon Skrine.)

Some early schools were tied to churches. The private schools that sprang up in Decatur often were started by church leaders or were housed in church buildings. The first African American public school classes were taught in a Presbyterian church. The relationships between church and schools continued into the 20th century as Decatur churches offered kindergartens, preschool, and private school classes. These photographs depict Francis Ripley's kindergarten class at Decatur Presbyterian Church (above) in 1957 and the kindergarten's teachers (below). (Both, courtesy Buddy Goodloe.)

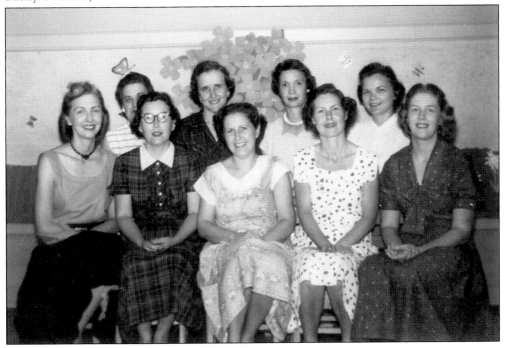

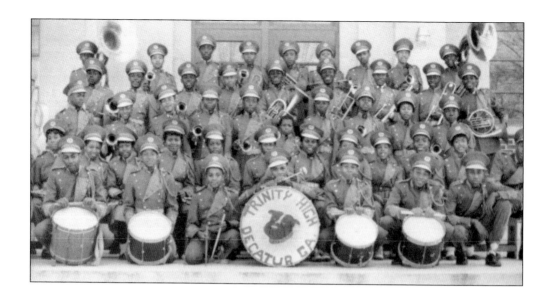

Trinity High School was built in 1956. It was the segregated public system's high school for African American students. It operated until it was merged into Decatur High School, which had educated white students. Both schools took the Bulldog as mascot and both took pride in their marching bands. Former Trinity student Sharon Skrine remembered that the Trinity band (shown above) played soulful music as it marched. Pictured below, the Decatur High Band periodically paraded through downtown Decatur, as in this photograph from a St. Patrick Day's parade some time during the 1940s.

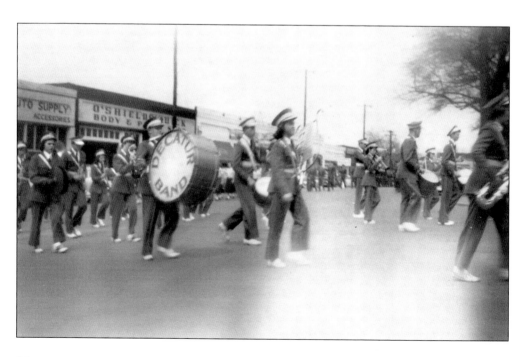

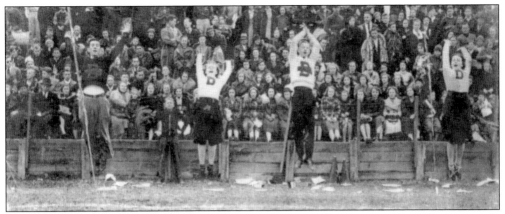

Decatur High School cheerleaders take to the air to encourage their team in this 1938 photograph. Sports programs were important to Decatur's schools, and the games drew crowds. Football was a special favorite. Fans were cheering football teams from the Donald Fraser High School before the city's public schools even opened. The public schools abandoned football for about five years after the 1915 season, when a star half-back died after his neck was broken during a game. The sport was revived in 1921.

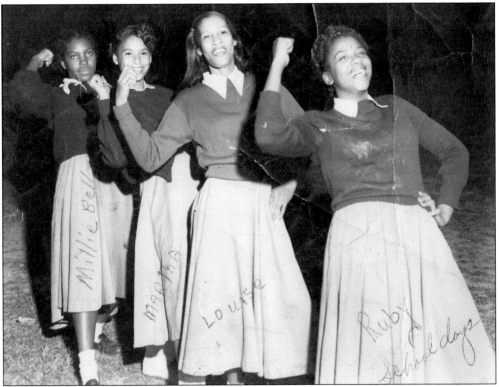

The Herring Street High School cheerleaders rouse the crowd in this photograph, taken around 1952. The cheerleader standing at the front of the group is Ruby Williams, who identified the others (from right to left) as Louise, Martha, and Millie Bell. The Herring Street School provided elementary and high school for Decatur's African American children from 1913 until 1956, when Beacon Elementary and Trinity High Schools replaced it. The Trinity football team was the state champion in 1965. (Courtesy of Sharon Skrine.)

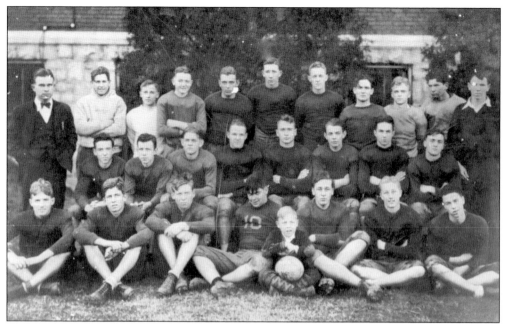

Decatur High School's sports programs date back more than a century, and many of the school's teams have been successful. Since 1948, when Georgia's high schools started a statewide ranking system, Decatur has won 19 state championships, including back-to-back championships in football in 1949 and 1950, riflery in 1952 and 1953, and girls swimming in 1953, 1954, and 1955. The football team of the 1930 season (shown above) won the title of Greater Atlanta champions. The 1940 team (shown below) included Frank Broyles, who is seated in the first row, the sixth from the left. Broyles went on to become a star player at Georgia Tech and a coach and athletic director at the University of Arkansas. (Both, courtesy of Eddie Fowlkes.)

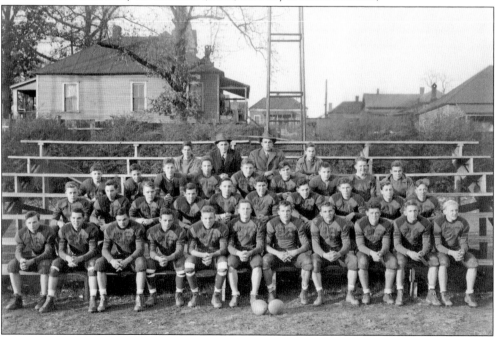

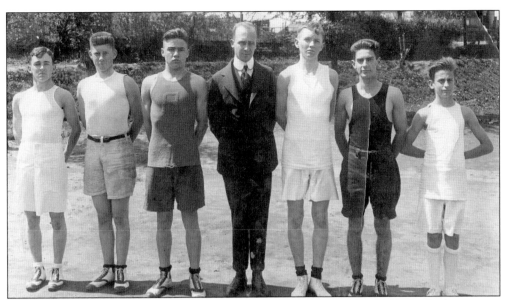

Athletic competitions go back to the earliest days of Decatur's schools. From the beginning, Donald Fraser School advertised its "commodious new gymnasium well equipped for pleasure and healthful exercise." In May 1919, Decatur High's track team, coached by Howell "Sudds" Watkins (pictured above at center), joined teams from Fairburn, College Park, Union City, Monroe, Conyers, Lithonia, and Kirkwood in a three-day competition that featured a track meet coupled with debates on women's suffrage and music, recitation of essays, spelling bees, and declamation competitions. The photograph below shows the 1937 track team. Note that players not wearing warm-ups suits are wearing Reserve Officer Training Corps (ROTC) uniforms. (Below, courtesy of City Schools of Decatur.)

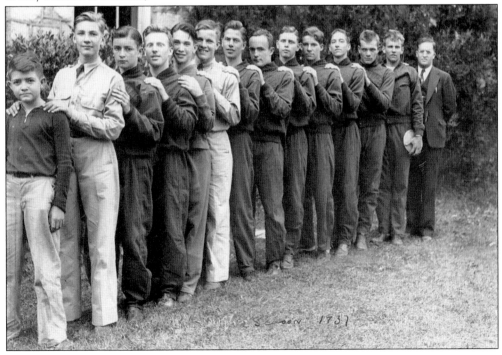

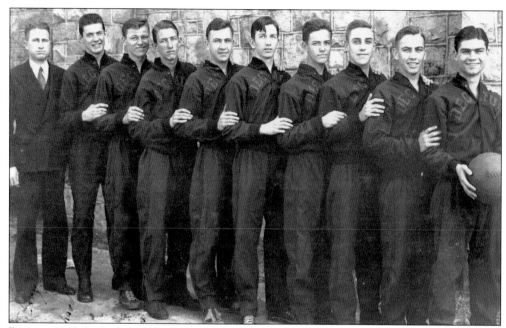

Decatur High basketball teams have competed since at least 1918. Pictured are the 1937 boys' team (above) and the 1920 girls' team (below). Both boys' and girls' basketball teams from Decatur have collected state championships. The boys' teams won championships in 1957, 1970, 1980, and 1982. The girls won in 1972. Other girls' athletic teams have proved successful, too. Decatur girls' swimming teams dominated state competitions in the 1950s and early 1960s, winning championships in 1953, 1954, 1955, 1960, and 1961. The girls' track team won the AA championship in 2006. (Above, courtesy of the City Schools of Decatur; below, courtesy of the Georgia State Archives, Vanishing Georgia Collection.)

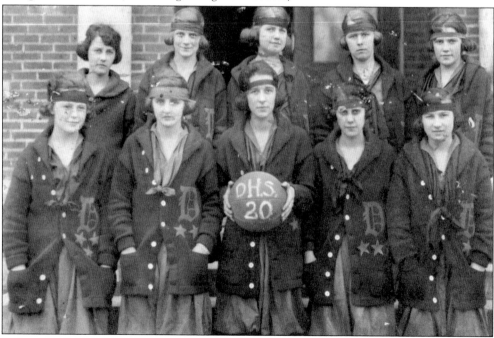

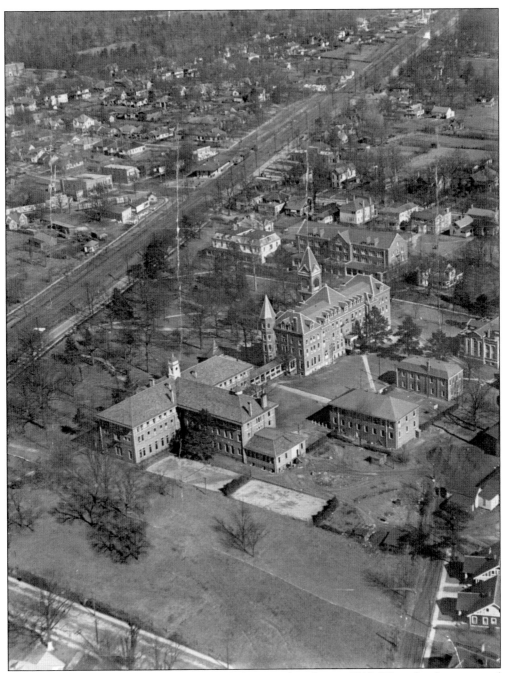

Agnes Scott College is shown in this aerial photograph, taken in 1923. The school was opened in 1889 as a primary school called the Decatur Female Seminary. The school was opened after Dr. Frank W. Gaines moved to Decatur in 1888 to become pastor of Decatur Presbyterian Church. Gaines thought the city needed a school. Once he arrived in Decatur, Gaines met George Washington Scott, a successful businessman and a member of Gaines's church who shared the minister's interest in setting up a school. They agreed to work together to establish a school for girls. (Photograph copyright, Agnes Scott College, used by permission.)

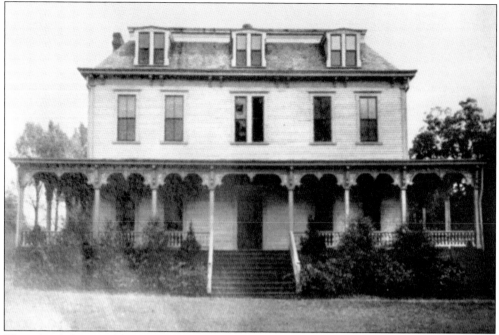

The school that would eventually be known as Agnes Scott College was first housed in this building, the home of Mrs. M. E. Allen. The building, called the White House, stood where Agnes Scott Hall (also known as Main) was located in 1891. The college moved the White House from its original site to a location near the corner of College and Candler Streets, where it was used as a dormitory or for storage until it was demolished in 1952. (Courtesy of Georgia State Archives, Vanishing Georgia Collection.)

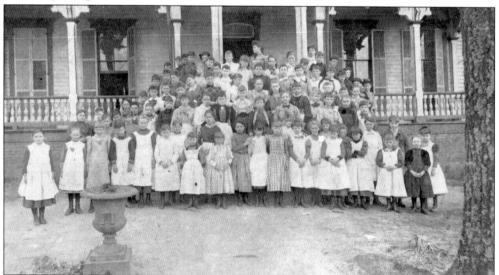

The Decatur Female Seminary's first class actually included a half dozen boys. But since 1891, when this photograph was made, the school has enrolled only girls and women. The school awarded its first bachelors degree as Agnes Scott College in 1906. It won accreditation in 1907, which made it the first Georgia institution of higher learning to receive regional accreditation. (Photograph copyright, Agnes Scott College, used by permission.)

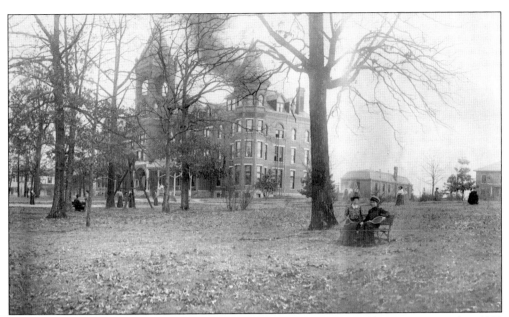

The college's signature brick building, with its tower, Agnes Scott Hall was constructed in 1891 and was the school's first building. Agnes Scott College grew up around it to eventually include more than two-dozen buildings, including an observatory. *The Princeton Review* recently named Agnes Scott's campus the second easiest college campus to get around. (Photograph copyright, Agnes Scott College, used by permission.)

The school was named for Agnes Irvine Scott, who immigrated to the United States from Ireland in 1816 and settled in Pennsylvania. The school took her name because she was the mother of Decatur businessman George Washington Scott, who helped found the school and contributed more than $100,000 to it in its early days. (Photograph copyright, Agnes Scott College, used by permission.)

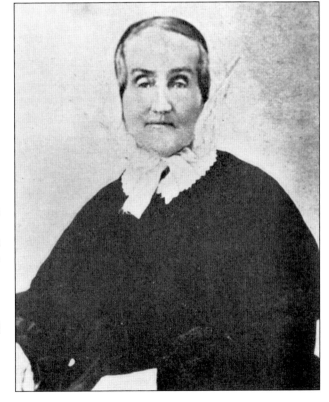

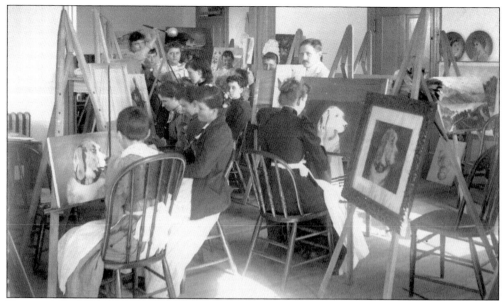

During the 1890s, the Agnes Scott Institute added grade levels to its elementary school until it offered high school and college-level classes. By the 1904–1905 school year, the high school and college were divided. The Agnes Scott Academy continued offering high school classes until 1912. The school offered its students a variety of subjects. These photographs show an 1892 art class (above) and a chemistry class from around 1912 (below). Several of the artists seem to be concentrating on portraits of dogs. (Photographs copyright, Agnes Scott College, used by permission.)

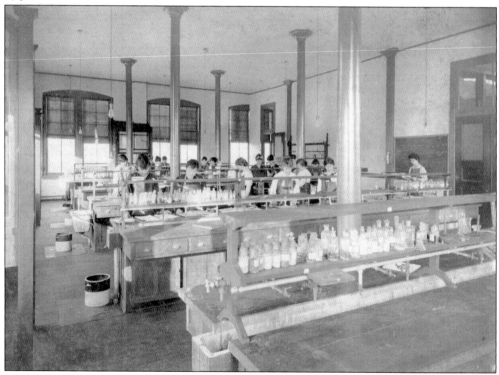

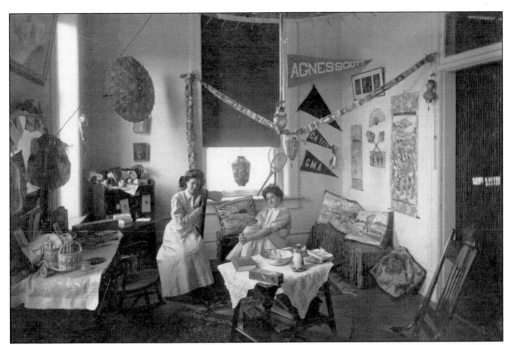

The clothes may change, but many things about college life seem to remain the same. Take dorm rooms. In the 1907 photograph above, two Agnes Scott students lounge in their dorm room, which is decorated with pennants for Georgia Tech and Agnes Scott and many throw pillows. In the photograph at right, taken in 1902, members of the Agnes Scott chafing dish club gather, presumably to discuss some of the finer points of keeping food warm. Perhaps they were simply hungry. In her history of Decatur, Caroline McKinney Clarke said early Agnes Scott students were prohibited from "eating imprudently at night." (Photographs copyright, Agnes Scott College, used by permission.)

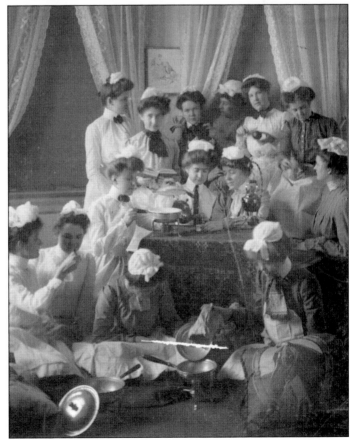

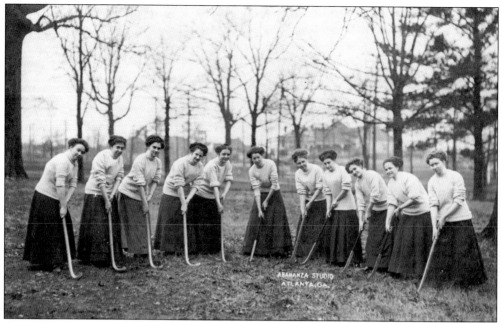

Agnes Scott students have taken part in athletics since the school's early days. In 1910, field hockey competitors (pictured above) demonstrated their fielding form in this group photograph. In 1932, Agnes Scott students showed their skill in archery (below). Agnes Scott teams, nicknamed the Scotties, now compete in a half-dozen sports. Agnes Scott teams take part in the Great South Athletic Conference, an association of National Collegiate Athletic Association Division III schools. The conference was founded in 1999. Schools in the GSAC conference are located in Alabama, Georgia, North Carolina, and Tennessee. (Photographs copyright, Agnes Scott College, used by permission.)

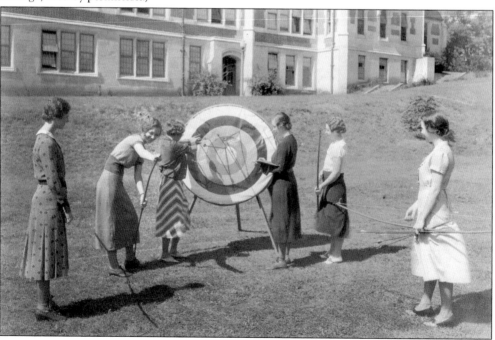

In the 1890s, Agnes Scott students operated under fairly strict supervision. In 1892, students were prohibited from wearing thin shoes in cold weather, sitting on the ground, and going outdoors with uncovered heads. The girls were also warned not to remove flannels early and were advised to put them on when the weather turned cold, Caroline McKinney Clarke reported in her history of Decatur. Things must have loosened up by the time these students took part in a parade on what appears, based on the way others are dressed, to have been a very cold day.

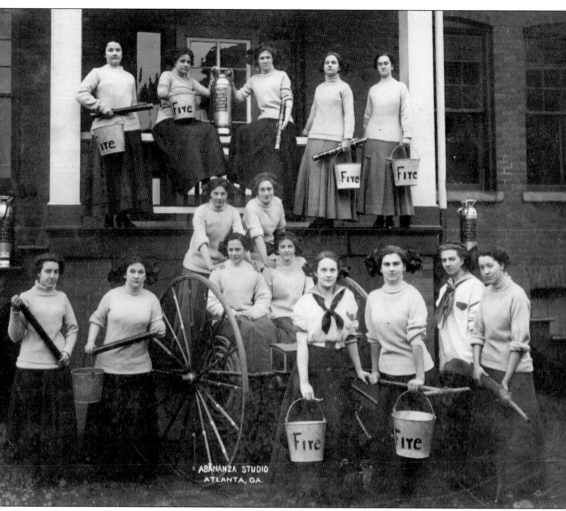

The City of Decatur's fire department traces its beginning to 1909, when the city bought its first chemical fire truck and offered eight residents a tax break if they would serve as volunteer firefighters. These Agnes Scott volunteers appear to be ready to take part in the fire fighting effort when they were photographed in 1910. (Photograph copyright, Agnes Scott College, used by permission.)

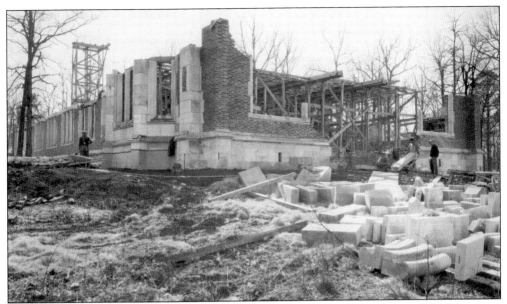

Construction of the Columbia Theological Seminary's brick-and-stone Campbell Hall began in the late 1920s when the seminary moved from Columbia, South Carolina, to its present campus in southeast Decatur. The Presbyterian seminary opened in 1828 in Lexington, Georgia, then moved to South Carolina in 1830. The seminary returned to Georgia, settling in Decatur, because of the metro Atlanta area's rapid growth as a commercial and cultural center. (Courtesy of Columbia Theological Seminary.)

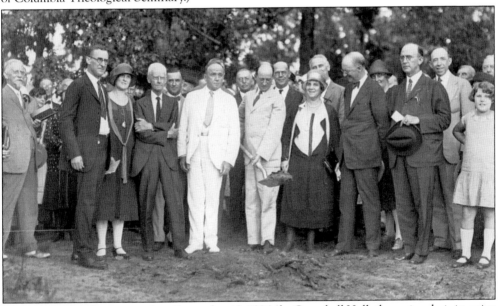

This group is breaking ground on September 13, 1926, for Campbell Hall, the main administrative building at Columbia Theological Seminary in Decatur. John Bulow Campbell, a major supporter of the seminary and a member of its board of directors, holds the shovel. The John Bulow Campbell Library is named after Campbell. The school's collection of books was originally housed in Campbell Hall. The separate library building was opened in 1953. (Courtesy of Columbia Theological Seminary.)

This group gathered around 1928 in Columbia Theological Seminary's dining room, then located in Campbell Hall. Campbell Hall takes it name to honor Virginia Orme Campbell, the mother of John Bulow Campbell, a major benefactor of the school. The building houses the school president's office, faculty offices, a chapel, classrooms, and other administrative offices. (Courtesy of Columbia Theological Seminary.)

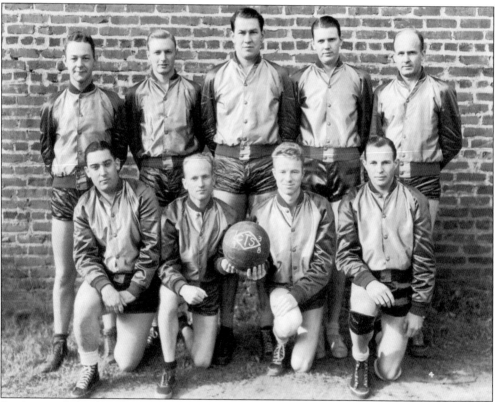

Students at Columbia Theological Seminary did more than simply study religious texts and learn to be ministers. They organized football and basketball teams, and competed in sports. This dapper group was organized as a basketball team in 1938. Some Decatur residents recall that seminary students regularly coached youth sports teams in recreation leagues throughout the city. (Courtesy of Columbia Theological Seminary.)

Four

PLACES OF WORSHIP

The first Decatur residents held worship services in their homes, but it was not long before the town sprouted churches. The Methodists and Presbyterians both built church buildings within a few years of Decatur's founding. After the Civil War, the Baptists built a church, too.

In his 1922 address celebrating the centennial of DeKalb County, Charles Murphey Candler pointed out that early preachers often did not live in DeKalb County but commuted from other, more populous areas. "As a rule, our forefathers who were church members were to a large degree consistent in their daily walk and enforced church discipline with a Puritan strictness, in striking contrast with the laxity of today," Candler said.

But that did not slow the growth of Decatur's churches. The city soon boasted new congregations. Existing churches built new, ever larger buildings as their congregations went through repeated growth spurts.

The first African American churches organized after the Civil War. Antioch African Methodist Episcopal Church was started in 1868, according to Caroline McKinney Clarke's history of Decatur, and Thankful Baptist Church was established 14 years later.

In the 1890s, the old downtown churches expanded into larger buildings. Soon residents of the Oakhurst community, who briefly operated their own separate town, apparently grew disillusioned with the downtown churches and started their own congregations. Their churches, like the downtown ones, prospered during the next several decades and in the years after World War II.

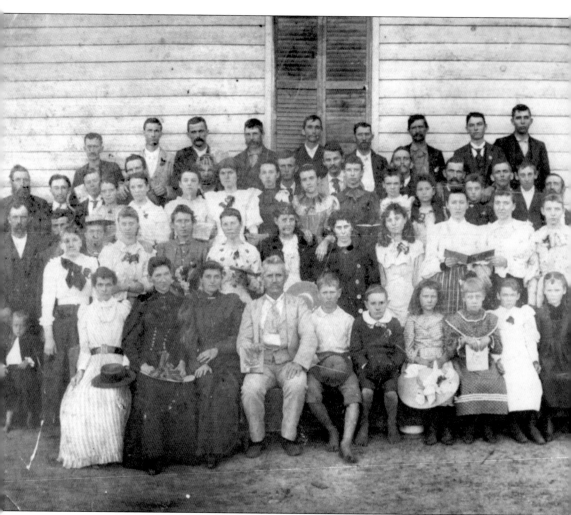

James L. White, photographed here at a singing school, taught the traditional form of hymn singing, which was called Sacred Harp singing. The capella tradition uses shapes to identify notes. It was named for *The Sacred Harp*. White's father, Benjamin Franklin White, and Elisha King originally published this song book. James White published a revised version, called *The New Sacred Harp*, in 1884.

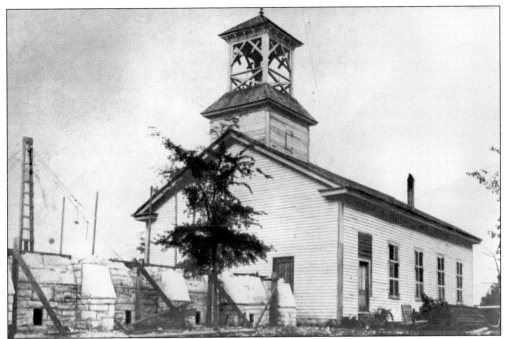

Decatur Methodist Church organized shortly after the founding of the town. A wooden church building was erected in 1826 on Sycamore Street. Church members say that it was the first building in Decatur used solely for worship. The white frame church shown in this photograph was built later, possibly in the 1850s. One history of the church says the date it was built is uncertain but that it was standing by 1868. (Courtesy of Georgia State Archives, Vanishing Georgia Collection.)

Work on the Methodist church's stone sanctuary on Sycamore Street started in 1897 and was completed in 1899. The sanctuary, now Decatur First United Methodist Church's chapel, was constructed of native granite and cost $6,626 to build. (Courtesy of Georgia State Archives, Vanishing Georgia Collection.)

Dr. John S. Wilson, who led a congregation in Lawrenceville, organized Decatur's first Presbyterian church, Westminster Presbyterian Church, in 1825. The Decatur church started with eight members. It was renamed Decatur Presbyterian Church when it was incorporated by the Georgia General Assembly in 1827. Decatur Presbyterian erected this brick building in 1846. The building later housed the Fraser School for Boys.

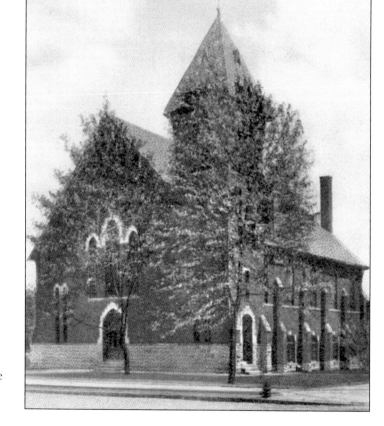

Decatur Presbyterian Church moved into a new brick church at the corner of Sycamore and Church Streets in 1891. The total cost of the building, including pews, furnishings, and an organ, was $25,000. Church member George Washington Scott donated the property.

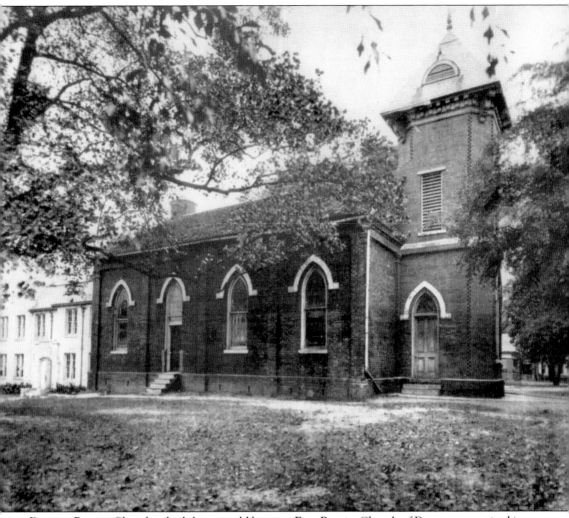

Decatur Baptist Church, which later would become First Baptist Church of Decatur, organized in 1862, during the Civil War. For years the congregation met in homes or other church buildings. The church's first building was a small, one-room chapel with a seating capacity of about 300. It was known as the "Little Red Brick Church." The first gathering in the building was held in April 1871. (Courtesy of First Baptist Church of Decatur.)

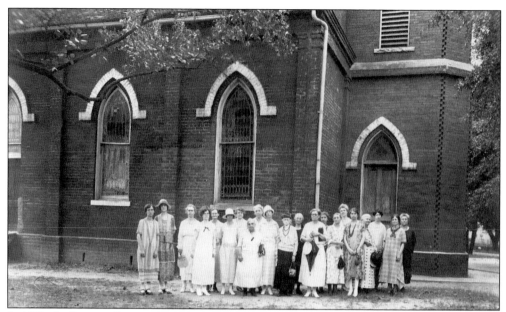

In 1910, the Decatur Baptist Church joined the new Atlanta Baptist Association. It is likely that this is the time, a church history said, that the church's name was changed to First Baptist of Decatur. Members of First Baptist Church's women's Missionary Society stand before the church in this photograph, taken around 1912. (Courtesy of First Baptist Church of Decatur.)

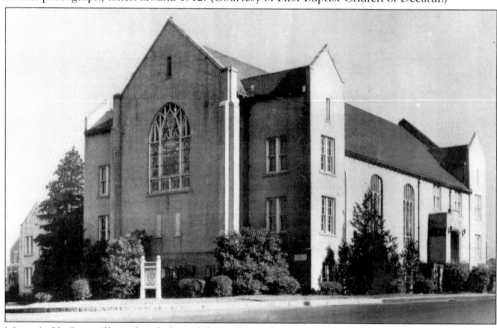

Mary A. H. Gay collected nickels and dimes from churches in Kentucky and elsewhere to raise $600, a significant portion of the total needed to build the Decatur Baptist Church's first building. By the 1920s, First Baptist had outgrown the redbrick church and began building its second home on the site of the first. When it opened in 1926, the headline in an Atlanta newspaper read, "Decatur Baptists to Open New $100,000 Church Today." (Courtesy of First Baptist Church of Decatur.)

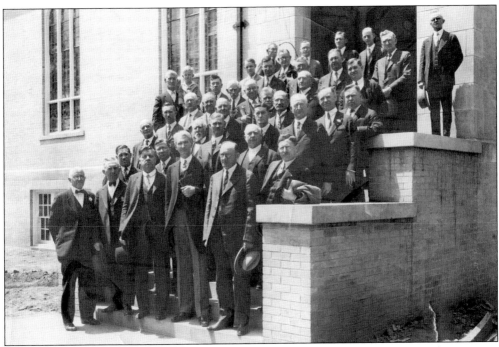

Decatur's First Baptist Church congregation expanded through the 1920s. "Business is humming at the Baptist church," one local newspaper reported, according to church historian Hettie Pittman Johnson. In the photograph above, members of the 1927 men's Bible class at First Baptist Church of Decatur stand on the steps of the then-new church building. Below, the T.E.L Sunday school class of 1927 gathers on the same steps. Pastor A. J. Moncrief and Sunday school superintendent Wheat Williams are in the top row. (Both, courtesy of First Baptist Church of Decatur.)

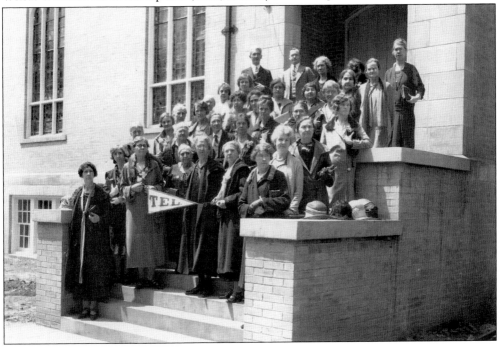

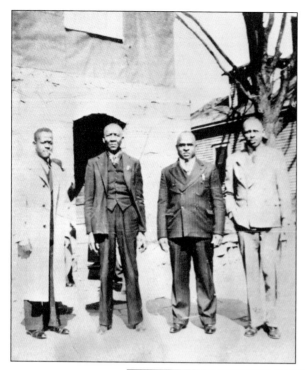

Thankful Baptist Church organized in 1882 after several African American families from Augusta and surrounding areas relocated to Decatur and found the city did not have a Baptist church for African American residents. Thankful Baptist was named for a church that several of the founders had attended in Augusta. Four deacons of the early church are pictured here. They are, left to right, James Bussey, Jake Sims, Arthur Kirkland, and Deacon Claude Clopton. (Courtesy of Georgia State Archives, Vanishing Georgia Collection.)

Members of Thankful Baptist Church held their first prayer meetings in private homes. In the early 1880s, they bought an old school building and converted it into the church. The church was located on Atlanta Avenue. Fire destroyed the original Thankful church building in 1970, and the congregation moved into a former Methodist church. (Courtesy of Georgia State Archives, Vanishing Georgia Collection.)

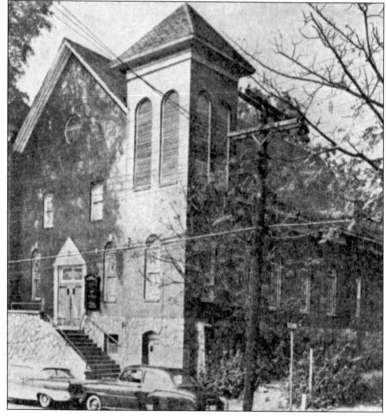

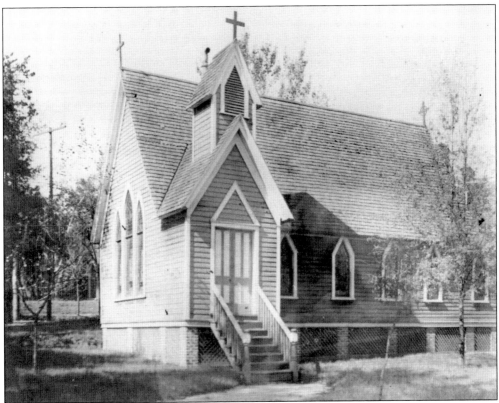

Episcopalians were counted among the early settlers of Decatur, but a separate Episcopal building was not constructed until long after other denominations had built separate church buildings. Holy Trinity's congregation organized with the help of 13 families in 1892. The parish's first building was erected in 1893 at the northeast corner of Trinity Place and Church Street. (Courtesy of Holy Trinity Episcopal Church.)

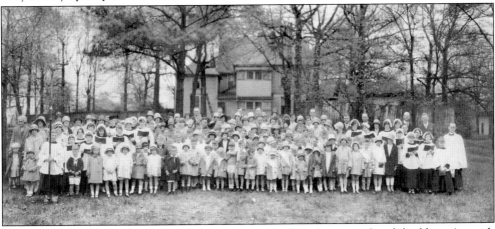

Holy Trinity bought land on Ponce de Leon Avenue in 1928 for a new church building. A parish house was built, and the second floor was used as a place of worship. In this photograph, members of the Episcopal parish gather in a field outside the building at some point in the late 1920s. Construction of the church was delayed until 1951, when a brick church opened on the Ponce de Leon property. (Courtesy of Holy Trinity Episcopal Church.)

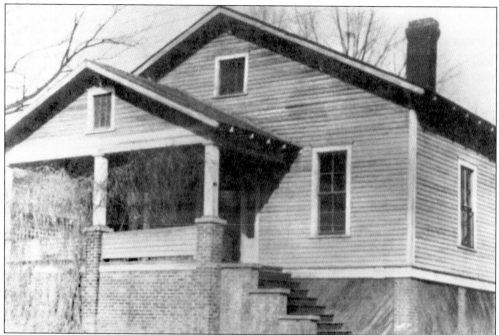

Mrs. C. J. Johnson's home on Melrose Avenue served as the birthplace of both Oakhurst Baptist Church and Pattillo Methodist Church. Oakhurst Baptist was organized in 1908 and was constituted in 1913 in what was then the town of Oakhurst, Georgia. The Georgia Legislature incorporated Oakhurst in 1910, but the town did not last long. The Legislature repealed Oakhurst's charter in 1914, allowing the area to be annexed into Decatur if the voters approved. In 1916, lawmakers ratified the annexation, but a short time after the election, the Oakhurst town hall burned, destroying all its official papers, which included all records of the election. (Courtesy of Oakhurst Baptist Church archives.)

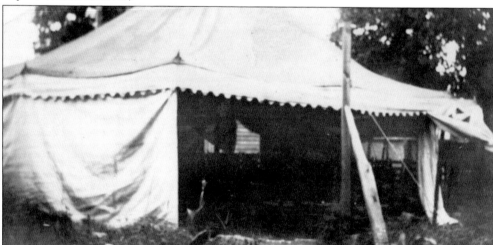

At first, Oakhurst's Methodists, Baptists, and Episcopalians held joint meetings. But by 1916, the group had outgrown the space available to it in the wood-frame house on Melrose Avenue, and members had begun to look for other meeting places. At some point, members of Oakhurst Baptist Church began meeting in a tent pitched in the backyard of a home at the corner of Park Place and East Lake Avenue. (Courtesy of Oakhurst Baptist Church archives.)

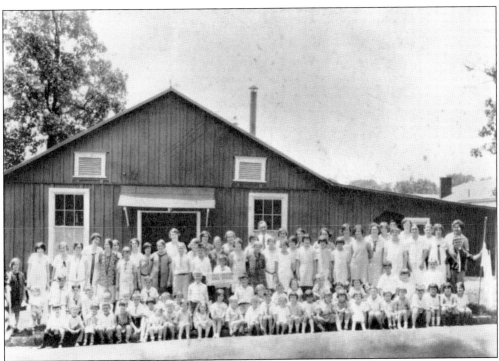

By 1918, Pattillo Methodist and Oakhurst Baptist separated. In 1920, Pattillo Methodist built a new church on College Avenue. In the following year, members of Oakhurst Baptist Church erected their own building, a wood-framed church that faced Third Avenue. In this photograph from the 1920s, members of the Oakhurst congregation line Third Avenue in front of their new church. (Courtesy of Oakhurst Baptist Church archives.)

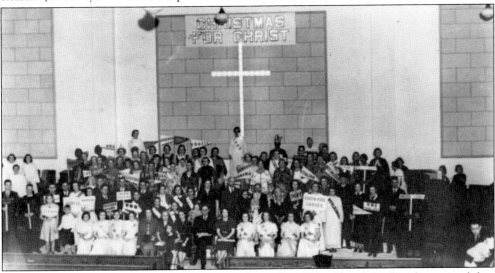

Oakhurst Baptist Church's expansion continued into the 1930s. Church leaders determined they needed a new, larger sanctuary to provide for the growing congregation, and ground was broken for a new building in 1932. By the time Oakhurst Baptist hosted this internationally themed pageant in 1935, the church's growth seemed unlikely to slow down. Other buildings were planned. An educational building was constructed behind the sanctuary in 1942.

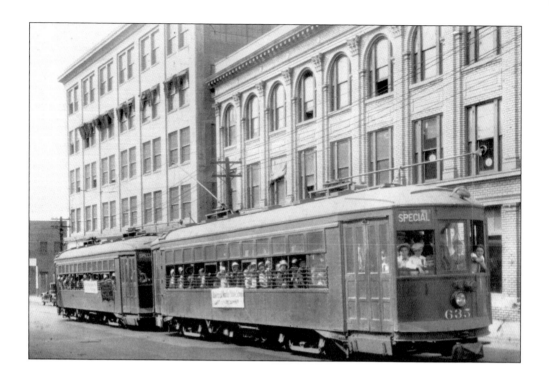

Oakhurst's churches grew quickly. By 1926, Oakhurst Baptist could pack two trolley cars with people willing to head to downtown Atlanta to take part in a gathering at the Baptist Tabernacle. That year Oakhurst Baptist won the attendance banner at an Atlanta Baptist Sunday School gathering by bringing 223 members to the Baptist Tabernacle for the event. It was the church's third attendance banner. Below, the group gathered outside the Baptist Tabernacle to pose for a celebratory photograph. (Both, courtesy Oakhurst Baptist Church archives.)

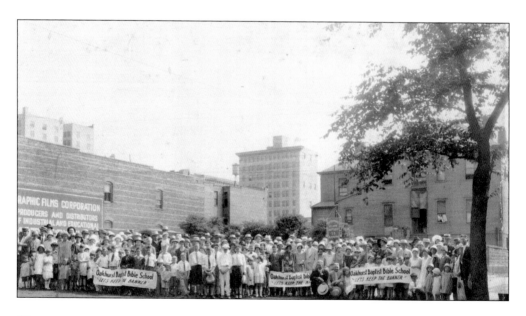

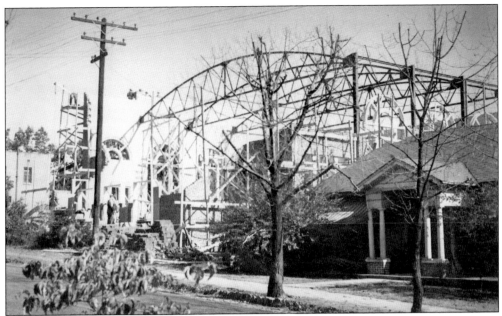

Oakhurst Baptist Church broke ground for its new sanctuary in 1932. Church officials decided to reorient the church so that it would face East Lake Drive rather than Third Avenue. The sanctuary was dedicated in 1937. The parsonage stood next door. By 1942, it could claim 1,359 members. In 1951, Oakhurst bought nearby property with plans to expand its buildings again. But in the 1960s and 1970s, the Oakhurst neighborhood started changing. African American families moved in, which made white people flee to distant suburbs. Some predominantly white church congregations joined the flight. Oakhurst Baptist's congregation decided to remain in its community, even placing a large piece of granite outside the church to show it intended to stay. The congregation integrated. Soon the church faced financial troubles. It dropped its expansion plans. The neighborhood continued to change, and the congregation changed with it. In the 1990s, as a result of Oakhurst Baptist's acceptance of homosexuality, the church was ousted from the Georgia Baptist Convention, the Southern Baptist Convention, and the Atlanta Baptist Association.

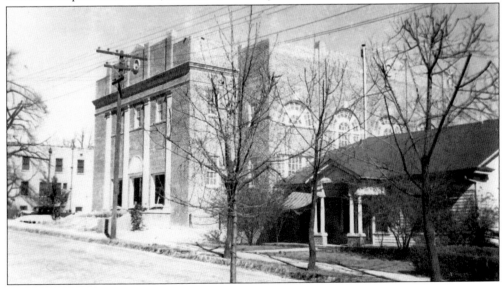

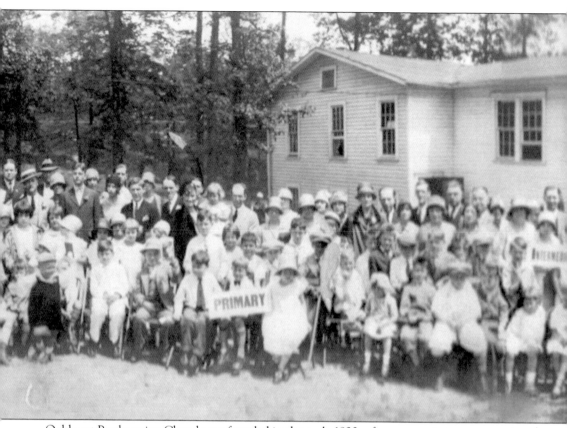

Oakhurst Presbyterian Church was founded in the early 1920s after a commission was appointed by the Atlanta Presbytery to organize a church in the Oakhurst section of Decatur. A small group of Presbyterians, Baptists, and Methodists met under a large tent on the corner of East Lake Drive and Second Avenue, according to the church. Eventually the groups separated into

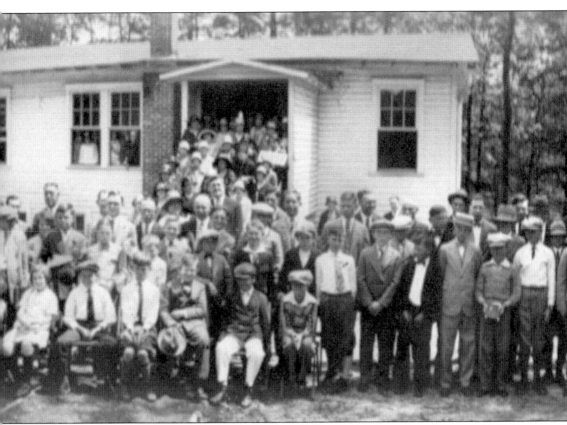

their own congregations. Membership in the Oakhurst Presbyterian Church reached 900 by 1960, church officials say, but in succeeding years, as African Americans began moving into the Oakhurst neighborhood, membership declined to as few as 80 members. (Courtesy of Oakhurst Presbyterian Church.)

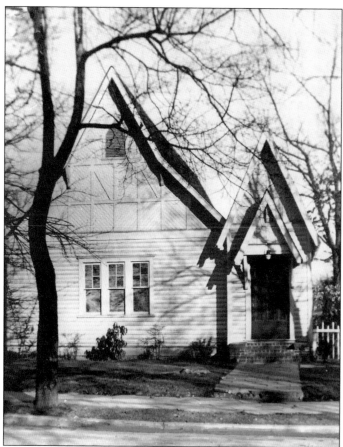

Until the 1920s, members of the Christian Church who lived in Decatur had to travel to Atlanta to attend services. On Christmas Day 1921, a small group established the First Christian Church of Decatur. The congregation built a wood-frame church at the corner of Adams and Ansley Streets that became known as "The Little White Church." (Courtesy of First Christian Church of Decatur.)

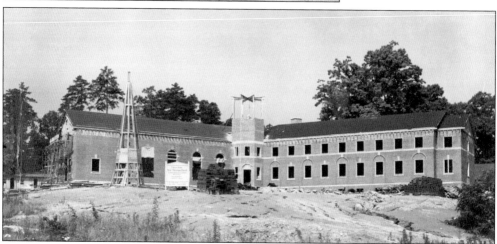

Decatur, like other metro Atlanta suburbs, grew rapidly in the years after World War II. Newcomers began to fill the town's institutions, including its churches. Several churches expanded. The First Christian Church of Decatur moved from its small, wooden church on Ansley Street to a much larger brick building on Ponce de Leon Avenue. In this 1950 photograph, the building is shown under construction, its unfinished steeple still sitting on the ground. (Courtesy of First Christian Church of Decatur.)

Five

THE COURTHOUSE

The Georgia Legislature created the Town of Decatur so it would have a place for DeKalb County to do business and to safely store its records. The public square that grew up around the DeKalb Courthouse has marked the center of the town's civic life since. The city expanded around the square. Businesses quickly located there. Crowds gathered at the square for civic celebrations or to mark important public events. Parades marched through the streets around the square. During World War II, war bonds were sold at the square as a sign posted by the courthouse marked the cost of war by recording the names of servicemen from the area.

While the public square has remained a constant in civic life, the courthouse building itself has changed repeatedly. Fires, changes in architectural tastes, and the simple need for more room for growing government agencies housed in the building have all given the DeKalb County Courthouse a variety of looks through the years. Some of DeKalb's courthouse buildings have been plain, while others have been fancy.

One early wooden courthouse burned, destroying many county records. County officials built a later courthouse from Stone Mountain granite, thinking it would be fireproof. It was not; that building burned, too.

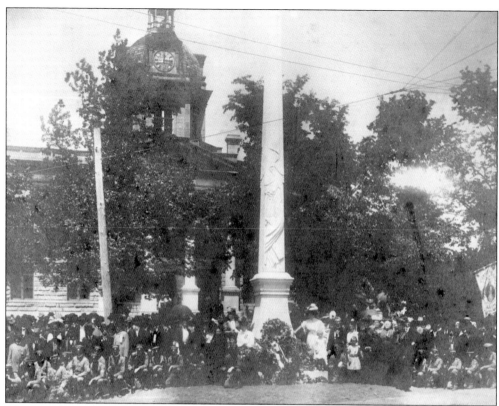

The DeKalb County Courthouse and the square surrounding it has always been a place Decatur residents gathered on important public occasions. This photograph portrays a gathering around the Confederate Monument, which was erected by the United Daughters of the Confederacy in 1909. The wreaths at the base of the monument and the gathering of men in uniform would indicate this group gathered to celebrate Confederate Memorial Day.

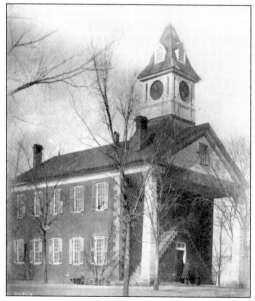

Depending on how you count, DeKalb County has built at least five courthouse buildings on the courthouse square. The first was a log structure on the north side of the square. The second building was made of brick, but it burned in 1842, destroying all county records. The third, the two-story courthouse pictured here, boasted granite columns on its eastern front. It stood until 1898, when it was razed so a granite-block building could be constructed in its place.

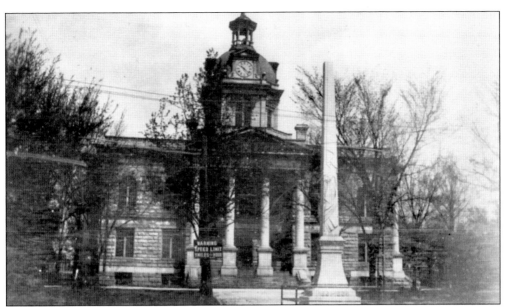

As the population of DeKalb County increased, county officials needed to expand the courthouse to handle the increase in county business. In 1898, they razed the rather plain 1842 courthouse and replaced it with one built of granite and boasting an ornate cupola topped with a statue of justice. The cupola contained clock faces. The building, the county's fourth courthouse, was designed to show off the community's growing population and wealth. Granite columns and steps rose to entrances on each of the four sides of the building. The words "county" and "courthouse" were carved above the doors, and in order to give the building a classy Roman appearance, the letter "U" was carved to look like a "V" in both words.

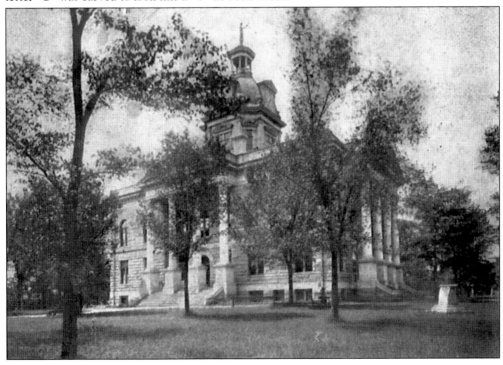

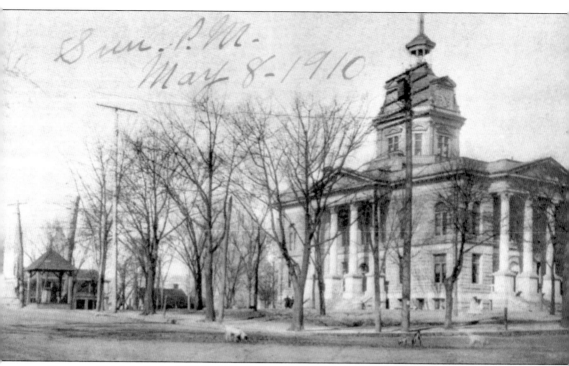

County officials built the 1898 DeKalb County Courthouse of granite so that it would be fireproof. It did not work. In 1916, the cupola caught fire. The blaze could be seen all over town. The fire destroyed the courthouse's fancy cupola, which was never replaced. Through the years, the square surrounding the courthouse has been modified along with the building. The small building at the left of this image housed a public well. The Confederate Monument was erected in front of the courthouse in 1909.

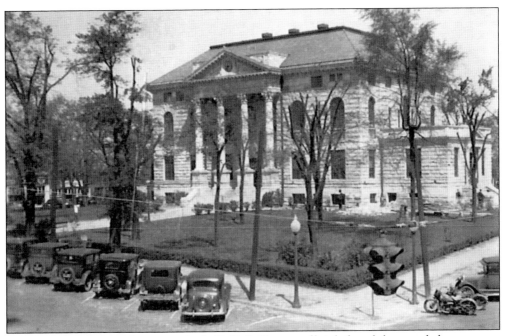

Not long after the courthouse was built, DeKalb County officials found they needed more room for county offices. After the 1916 fire, they decided to expand the courthouse and added two one-story wings to the east and west sides of the building. The east and west entrances, with their steps and columns, were removed. Eventually a second level was added to the wings.

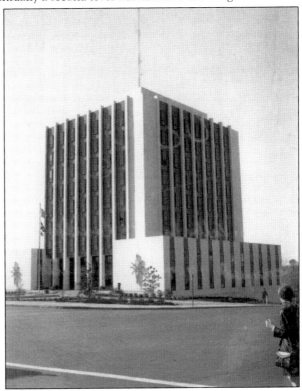

The demands for office space to house DeKalb County's government continued to exceed the space available in the old DeKalb County Courthouse, so county officials decided in the mid-1960s to build a new high-rise courthouse. The courthouse, which has been expanded since it was built, is located just off Decatur square. The DeKalb History Center now occupies what has come to be called the Old Courthouse.

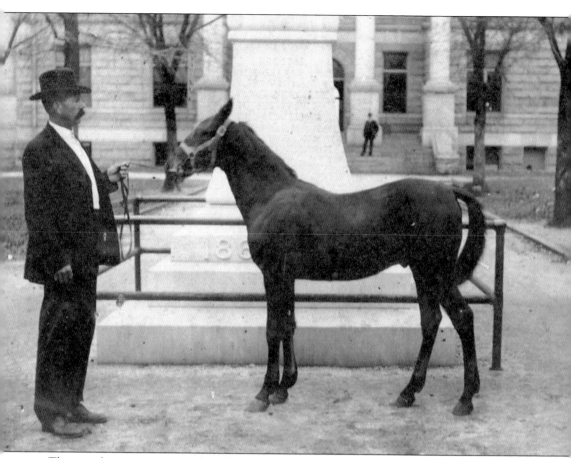

The courthouse square served as the commercial center of Decatur and DeKalb County as well as the seat of government. It also served as a place to show one's finery and finest possessions, whether elegant hats worn for public occasions or parades of early automobiles. In the early 1900s, a man named Tom Adams brought this horse to the courthouse square, where they were photographed.

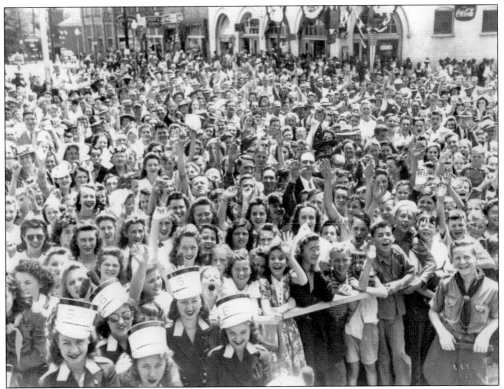

The courthouse square is Decatur's public meeting place. Crowds gather there regularly for civic events, commemorations, and celebrations. During World War II, war bond rallies like the one shown above drew mobs. This rally apparently drew an especially cheerful crowd, because movie actress Dorothy Lamour was expected to make an appearance as a special guest. Elsewhere on the square, a huge bulletin board listed the names of all the DeKalb County men serving in the armed forces. DeKalb erected a monument to those who died in service in the square.

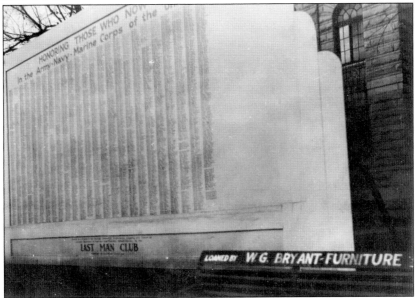

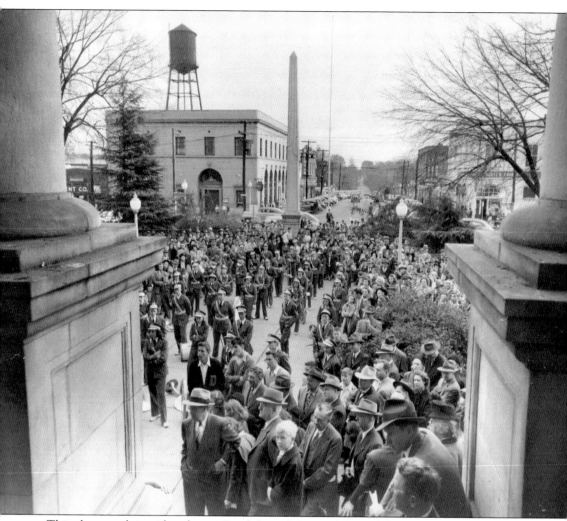

This photograph is said to show a Confederate Memorial Day celebration on April 28, 1958. As the civil rights movement changed the face of the South in the 1950s and 1960s, many whites reacted or expressed resistance by looking to the past. About a half century after the Confederate Monument was erected on the courthouse lawn, this large group gathers on the south steps of the DeKalb County Courthouse.

Maury F. Mable was Decatur's one-man St. Patrick's Day Parade. Dressed in top hat, spats, and swallowtail coat, he marched to honor Ireland, the homeland of his mother. He started the parades in 1895 and continued them for about half a century. Over the years, the annual event drew crowds to downtown Decatur to watch as Mable, followed at times by the Decatur High School marching band, strutted through the downtown streets.

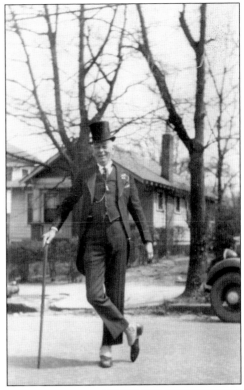

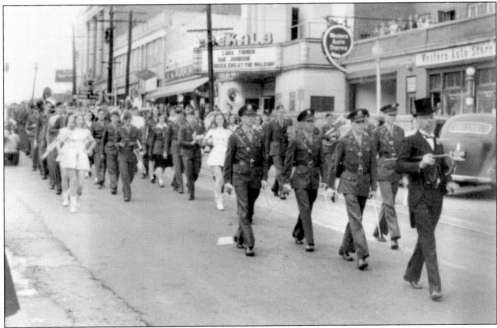

Maury F. Mable leads the St. Patrick's Day parade through downtown Decatur. He was joined by members of the Decatur High School ROTC program and the high school marching band in this photograph from the 1940s. At first two other men accompanied him, but for years he marched alone or was accompanied by anyone who wished to join in.

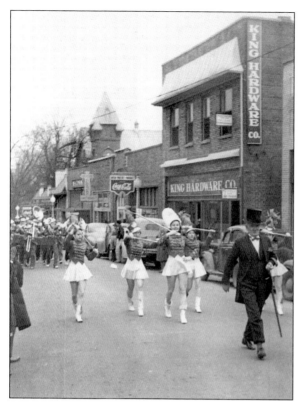

DeKalb fire chief Mike Lynch began performing the annual St. Patrick's Day Parade after his friend, parade founder Maury F. Mable, could no longer make the march. Lynch was born in Ireland, immigrated to the United States at age 13, and settled in DeKalb in 1940. He was quoted in a newspaper article as saying, "When I read in a London newspaper back in County Leitrin in 1914 about Maury Mable stagin' a one-man St. Patrick's Day parade, I never dreamed I would one day be a-carryin' on for him."

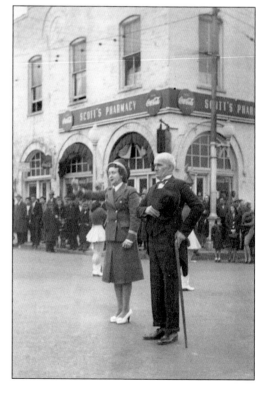

St. Patrick's Day enthusiast Mike Lynch inherited the one-man parade from his friend Maury F. Mable. Lynch, in turn, groomed his grandsons, Joe and Jimmy Herbermann, to take over from him. Joe Herbermann first took over at age 13 when his grandfather was hospitalized. Herbermann inherited the job upon his grandfather's death in 1954.

Six

CITY GOVERNMENT

Decatur's first city government, according to Charles Murphey Candler, was a group of commissioners appointed by the Georgia Legislature. "Only recently have we gone back to a commission form of government," Candler said in 1922 during an address to mark DeKalb County's centennial, "as if it were a new thing for Decatur." Today city government is still run by five commissioners who choose one of their members to serve as mayor and one to serve as vice mayor.

Decatur remained small for much of the 19th century. In the 1870s, the city contained just a few hundred residents. Decatur's officials were able find ways to stay busy. In 1873, Caroline McKinney Clarke reports in her history of Decatur that the city government adopted a number of ordinances governing conduct in the city. Fines of $25 could be assessed on any person who committed acts of public indecency; fired a gun; fought chickens or dogs; left trash on the square and failed to remove it within six hours after a warning; or allowed goats, hogs, cattle, or horses to run loose in the city streets. That commission also made it a crime to "willfully destroy or injure any shade tree."

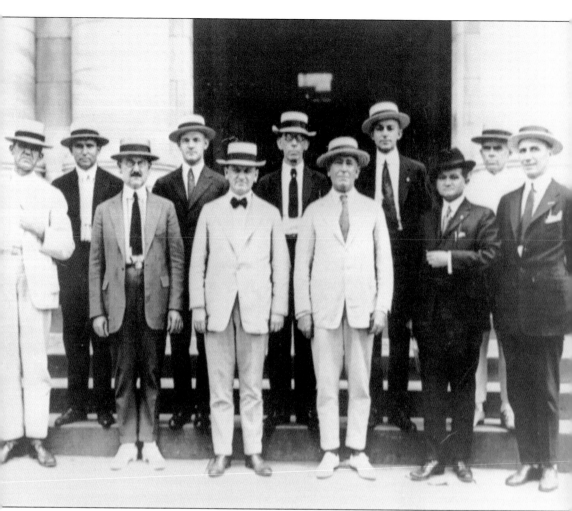

In 1873, Decatur's city government was composed of a five-member commission with a chairman but no mayor, according to Caroline McKinney Clarke's Decatur history. In 1882, the town charter was amended to create a six-member council and the post of mayor. The first mayor was Ernest M. Ward. This group photograph of Decatur commissioners was taken in 1920. From left to right are (first row) commissioners R. E. White and Guy Webb, city manager P. P. Philcher, commissioners W. J. Dabney, C. Eugene Allen, and Homer George; (second row) city clerk A. R. Almon, Howard Sharp, city attorney J. Howell Green, Dr. Jim Pittman, and police court judge Frank Harwell. (Courtesy of Georgia State Archives, Vanishing Georgia Collection.)

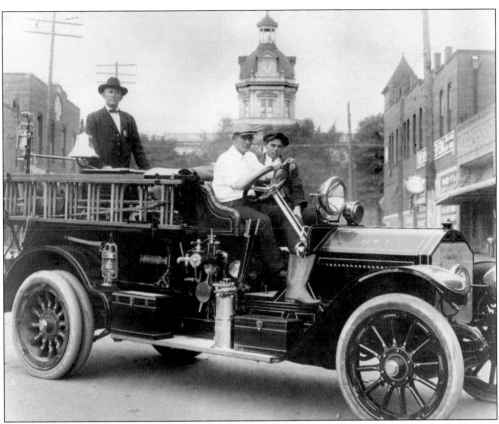

Fire fighting started in Decatur in 1909 when the city bought a chemical fire truck, the first in DeKalb County. The city appointed eight men to act as volunteer firefighters, and in return for their service, they were excused from paying city property taxes. Over the next several years, the city bought other trucks, including the 1914 American LaFrance fire engine shown above. M. D. Googer, who later was elected fire chief, stands in the back, and Howard Ehle, one of the city's first paid firefighters, takes the wheel, with his passenger Ulrich Green. The DeKalb County Courthouse's cupola, which was destroyed in a 1916 fire, rises behind the truck. (Courtesy of Georgia State Archives, Vanishing Georgia Collection.)

For years, Decatur housed its fire engines at city hall. In 1947, a second station was built at 356 West Hill Street to provide fire protection in the southern part of the city. In 1952, a new Station No. 1 was opened at 230 East Trinity Place (shown at right). The 800-pound steel alloy fire bell used to summon volunteer firefighters is displayed in front of the building.

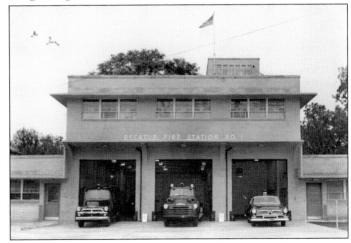

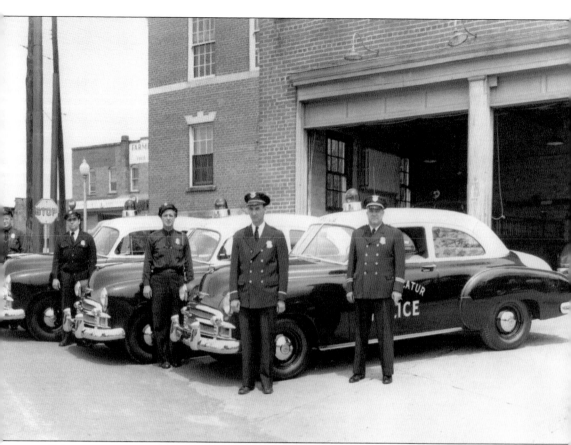

Police protection in the city goes back to at least 1891, when two watchmen, afterwards called marshals, were given arrest powers. The marshals were required to wear uniforms and were allowed to carry pistols. In 1910, M. D. Googer was elected marshal. By 1915, he was serving as marshal, police chief, fire chief, and head of the sanitation department. His salary was $100 a month.

DeKalb County's jail stood at the corner of McDonough and Herring Streets (now Trinity Place) until shortly after World War II. Until 1925, the law required the jail to serve not only as a place to house prisoners, but also as the residence of the sheriff. The sheriff's wife cooked meals for the prisoners.

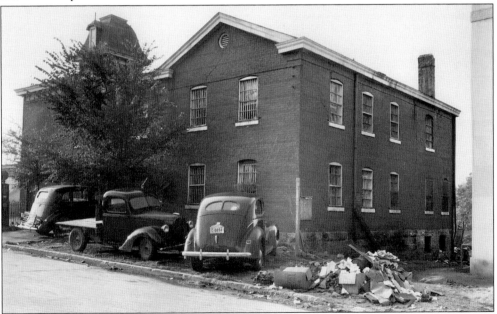

The first jail of DeKalb County, like the first DeKalb County Courthouse, was a log building. It stood about two stories tall and had a dungeon where prisoners were held. A trap door in the floor offered the only entrance into the dungeon. As the city grew, so did the jail, as illustrated by this photograph showing the barred windows of the jail annex.

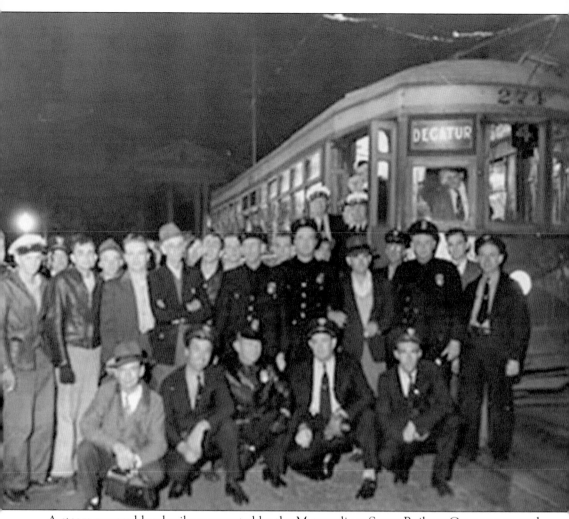

A steam-powered local railway operated by the Metropolitan Street Railway Company started service in Decatur in 1891. A small steam engine pulled cars from what is now College Avenue by Agnes Scott College to Alabama and Pryor Streets in downtown Atlanta. Electric streetcars began service in 1894 and continued until 1946, when trackless trolleys replaced the streetcars that ran on tracks. The trackless trolleys were discontinued in 1963.

Seven

COMMERCE

Commerce Street now winds around downtown Decatur, serving as a way for traffic to bypass the square. But commerce has been a part of Decatur's makeup since its earliest days.

The town attracted small dry-goods stores that sold to farmers from the surrounding countryside who could not afford to take several days off in order to make a cross-county trip to markets in Augusta. Early accounts say there may have been as many as nine or 10 merchants in early Decatur selling anything from gingham to peach brandy. In the late 19th century, shops expanded to general merchandise outlets, as Decatur merchants offered a greater selection of goods

In the mid-20th century, during its heyday as a marketplace, downtown Decatur seemed to attract just about every sort of business a small town could offer: banks, restaurants, dime stores, shoe shops, and drugstores. Competition seemed natural, and there often were two or more versions of each type of store.

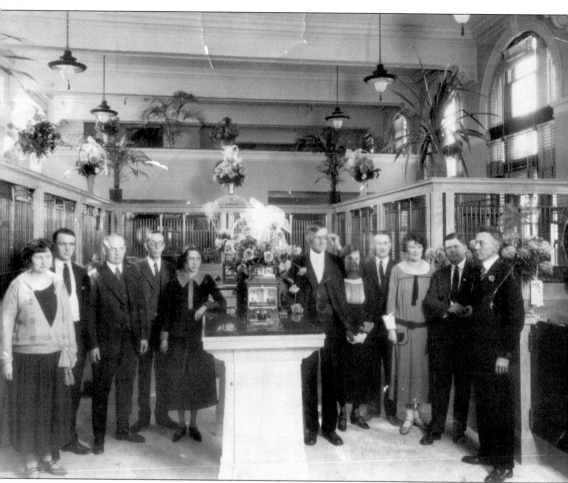

Employees of the Bank of Decatur welcomed customers with showy vases of flowers in this portrait of the bank and its staff. Bank vice president W. H. Weekes, who stands with his hand to his glasses, and bank president W. F. Patillo were original officers of the bank. Among those pictured with Weekes are a Mrs. Sanders, Jim Battle, J. Howell Gain, Clara Weekes, Fannie Mae Henderson, Alton Langley, Mildred King, W. C. McLain, and a Mr. Sanders. The bank was chartered in 1906 with $25,000 in capital. In 1920, the bank became Decatur Bank and Trust, and its capital was increased to $100,000.

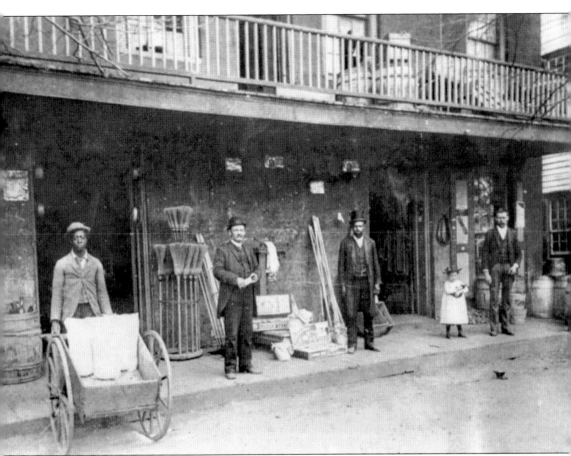

George Ramspeck, a German immigrant, started a store in Decatur, and his son, Thomas, later took it over. Their business, known as the "brick store," stood on East Court Square. It burned in the early 1890s. The people in this 1880s photograph have been identified as, from left to right, Will Stancil, who later was pastor of Antioch Methodist Church; George Ramspeck; Preacher Scruggs, a pastor of Thankful Baptist Church; Annie Jones; Hamilton Weekes; and Florie Jones. (Courtesy of Georgia State Archives, Vanishing Georgia Collection.)

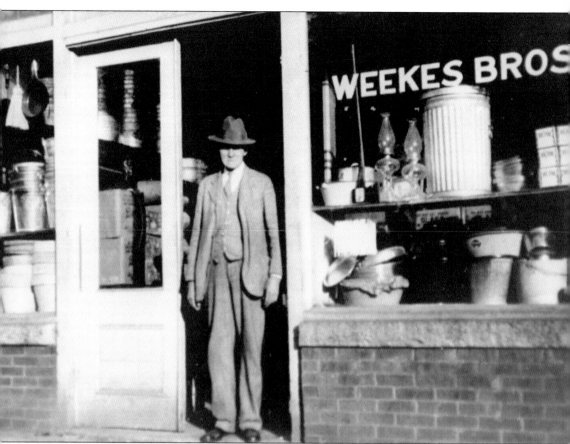

Hamilton Weekes stands in the East Court Square entryway to the Weekes Brothers Store. Hamilton, Polemon, and Charles Weekes operated the store, a Decatur institution from 1898 until 1940. Their store sold a wide range of things, including groceries. The grocery entrance was located around the corner on Sycamore Street. (Courtesy of Georgia State Archives, Vanishing Georgia Collection.)

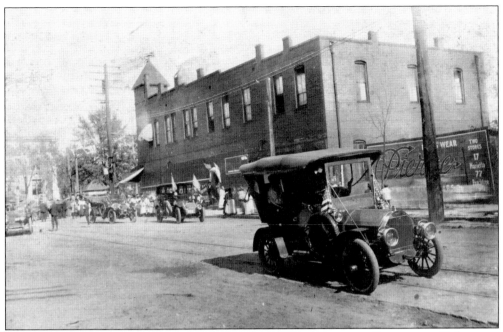

Cars decked out with U.S. flags—said to be among the first cars in Decatur—roll down an unpaved McDonough Street some time between 1912 and 1916. Note the old DeKalb County Courthouse at the end of the street. At the time, the south end of the courthouse, where the Confederate Monument was located, was considered to be the front of the building. (Courtesy of Georgia State Archives, Vanishing Georgia Collection.)

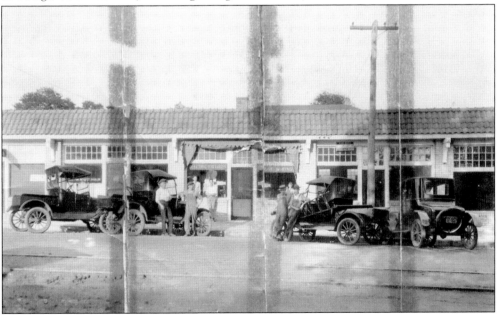

The square around the DeKalb County Courthouse served as a gathering point for farmers who lived in the countryside around Decatur. They depended on the city's shops for goods and used the square as a place to gather and chat. In this 1920s photograph, a group of pickup drivers found the square a place where they could park for a while and show the world their trucks.

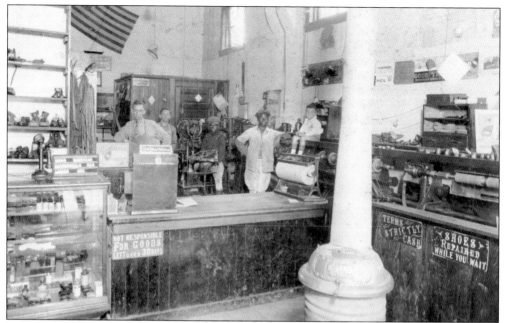

Bailey's Shoe Shop opened on the courthouse square in 1904. It was owned and operated by three generations of the Bailey family. J. C. Bailey, the last owner, started working in the business at age 13. He continued working there until he retired and closed the shop in the 1960s.

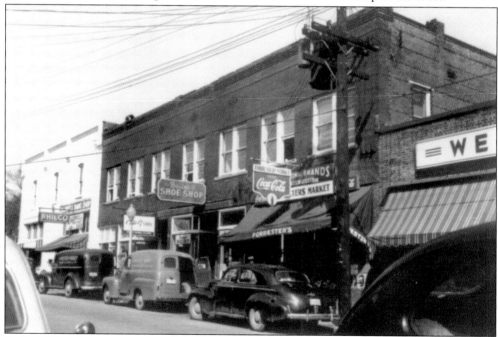

Bailey's Shoe Shop operated in downtown Decatur for more than half a century. At one point, the business was moved from Atlanta Avenue to a new space on Sycamore Street. The two streets connected, and the name of the street changed from Atlanta to Sycamore when the streets met in front of the courthouse. Shoe shop owner J. C. Bailey joked the move meant Bailey's would be on the "same street, different name."

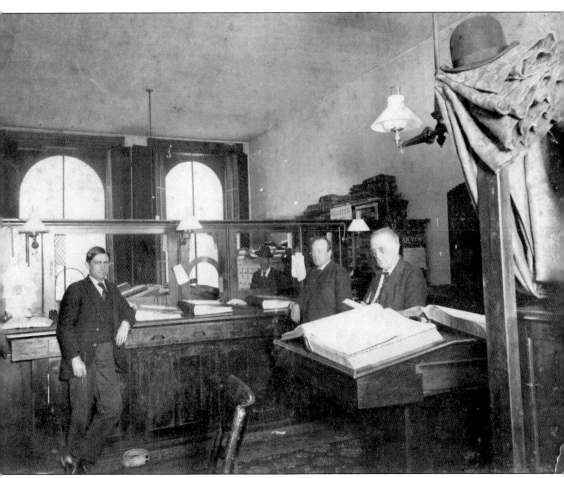

The Bank of Decatur was chartered in 1906, around the same time this photograph was taken. The bank's initial capital included $15,000 in cash from investors and $10,000 that could be called in. In 1927, a newspaper report in the *Atlanta Constitution* called the bank "the oldest of Decatur's financial institutions," and after the founding, it "quickly made a name for itself in the business and agricultural life of DeKalb County."

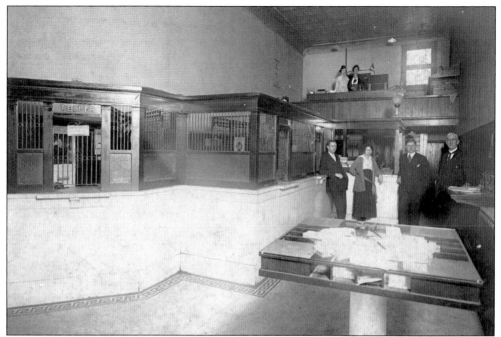

Bank of Decatur cashiers and founding first vice president W. E. McCalla gather at the bank for a portrait dated to 1919. In its early years, the Decatur bank appears to have been successful. In 1924, the *Atlanta Constitution* reported, "Because of a reputation earned by its liberal policy toward farmers, businessmen, and enterprises that came to Decatur and DeKalb County, the business of this institution is said to have enjoyed a steady increase from the day of its inception."

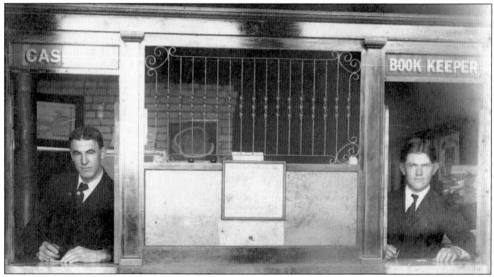

Tellers man their windows in this Bank of Decatur portrait dated to 1919. The bank closed in 1931. The Decatur Development Company was organized to handle the affairs of the defunct bank. A 1933 article in the *Atlanta Constitution* said more than 3,000 depositors in the bank were to be paid off in full that year with a $340,000 loan from the Reconstruction Finance Corporation. The Decatur Bank was the first Georgia bank to pay off depositors with such a loan, the newspaper said.

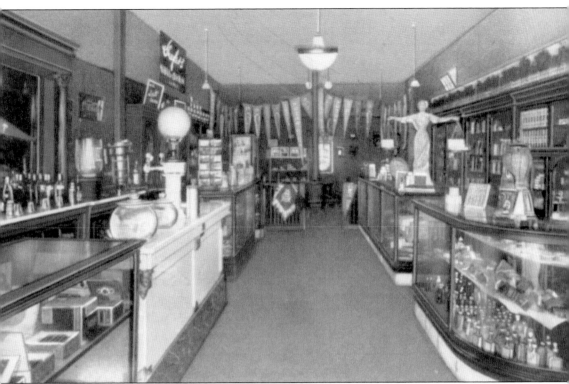

Meeks Drug Store offered a variety of merchandise other than drugs. Shops like Meeks typically served as a combination of soda fountain, cigar stores, candy counter, postcard shop, and community gathering place. In this postcard view of Meeks's interior, the shop also appears to be a community booster, considering the Agnes Scott pennants it offered.

The Hotel Candler occupied the corner of Ponce de Leon Avenue and Church Street. Built by a group headed by Walter Candler, son of Coca-Cola Company founder Asa Candler, the Hotel Candler was intended to rank among the country's finest hotels when it opened in 1927. About 5,000 people attended the hotel's grand opening, and the Atlanta Symphony played at the opening reception. One brochure suggested the hotel could serve as a convenient stopover for travelers bound from New York to Miami. The hotel was demolished in 1984 for construction of an office building.

European Plan ❖ Rates Reasonable
COMMENSURATE WITH SERVICE RENDERED
Hotel CANDLER Decatur Georgia
Telephone CRESCENT 6491
L.L. TUCKER, JR. WALTER T. CANDLER
Lessee-Manager Owner

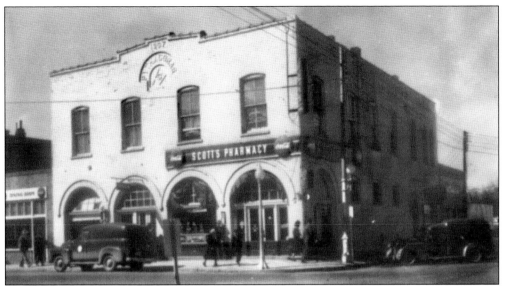

Occupied by the Pythagoras Lodge, this building at the corner of McDonough and Sycamore Streets was the fourth of five locations on Decatur's courthouse square. The Masonic group started in 1844 in a building on the north side of the square, according to Caroline McKinney Clarke's history of Decatur. Later the lodge was moved into a two-story building erected at the intersection of West Court Square and Atlanta Avenue. The lodge's third building was on the southeast corner of McDonough and Sycamore Streets. In 1907, the group constructed this building on the southwest corner of McDonough and Sycamore.

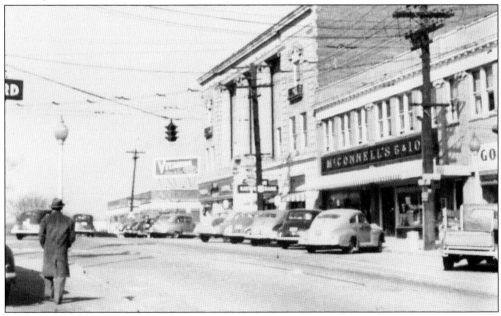

Four moves apparently were not enough for the Pythagoras Lodge. The Masonic group built this columned building on the corner of Ponce de Leon and Clairemont Avenues in 1925. All five lodge buildings stood on the courthouse square. The construction of the fifth building brought the lodge back to the place where it had started, on the north side of the courthouse square. The Fulton National Bank occupied a portion of the first floor when this photograph was made.

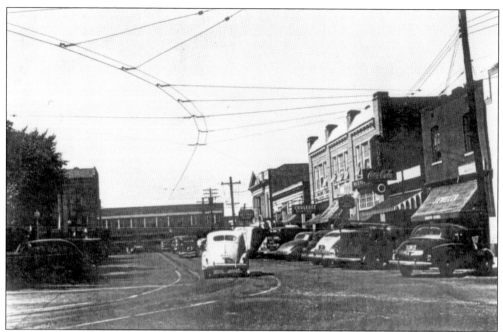

The two views of East Court Square from the 1940s show how a variety of shops filled the buildings around the DeKalb County Courthouse before the development of malls outside the city siphoned off their customers. The electric streetcar brought shoppers to the square, but even then it appears parking on the square could be a problem.

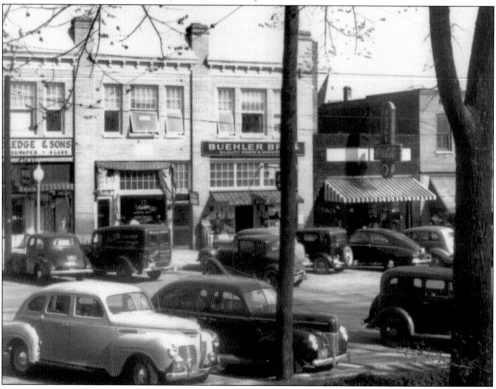

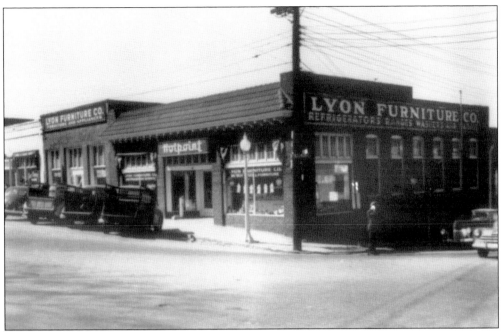

On the opposite side of the DeKalb County Courthouse from East Court Square stood West Court Square, which is shown here in a photograph probably taken in the 1940s. At the time, the streets around the courthouse created an actual downtown square. Shops lining the square offered merchandise ranging from jewelry to groceries to furniture.

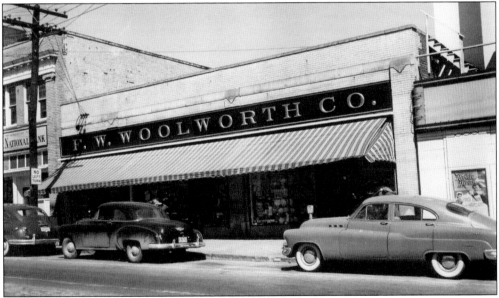

At its peak as a shopping district, the courthouse square served as the commercial center not just for Decatur, but for much of the surrounding county as well. Downtown Decatur offered plenty of competition among shopkeepers. This F. W. Woolworth Company store on East Ponce de Leon Avenue stood just one or two buildings down the street from another five-and-dime store. There were several banks competing for Decatur's business, and it seemed like a drugstore stood on nearly every side of the square.

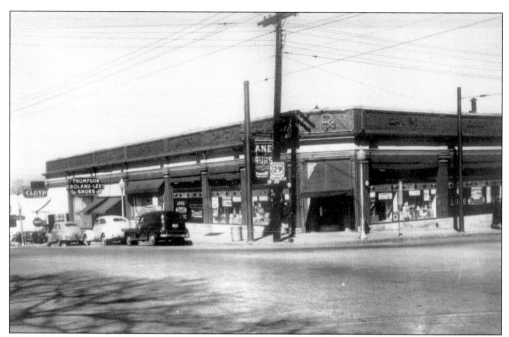

Lane Drug Store, at the corner of Clairemont and Ponce de Leon Avenues, provided a popular gathering place on the courthouse square. Located on the northwest corner of the square, Lane's was among at least three drugstores that operated on or near the square at the same time. In the 1940s, commuters would ride a trolley to the square and then call home from the drugstore in order to have someone come pick them up.

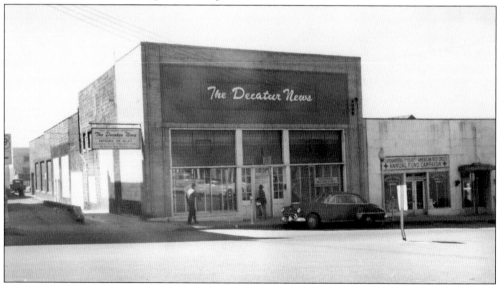

Newspapers started appearing in Decatur in its earliest days. The first was called the *DeKalb Gazette* and was published by Samuel Wright Miner, who owned a print shop and worked as the newspaper's editor and printer, as well as its publisher, according to DeKalb historian Vivian Price. The *Decatur News* opened for business in 1949. It circulated about 5,000 copies in and around Decatur until 1960. In that year, it became the *Decatur-DeKalb News* in the first of a series of name changes. By the 1970s, its circulation had grown to about 70,000.

Eight

CHARITY

After the Civil War, a Methodist minister named Jesse Boring returned to his home state of Georgia to find it devastated by the conflict. Families had splintered. Farms were ruined. Orphans and abandoned children wandered the countryside looking for food and shelter.

Dr. Boring was horrified. He started a campaign to found a home for the children made homeless by the war. In 1869, a group of Methodists started the home near Norcross. In 1873, after a fire damaged the Norcross facility, the Methodist Children's Home was moved to 218 acres on Snapfinger Drive (now known as Columbia Road), south of Decatur. The home has operated at the site since.

Dr. Boring died in 1890 at age 83. His remains were buried at the children's home in Decatur. His headstone reads, "He who turns a child to God changes the course of history."

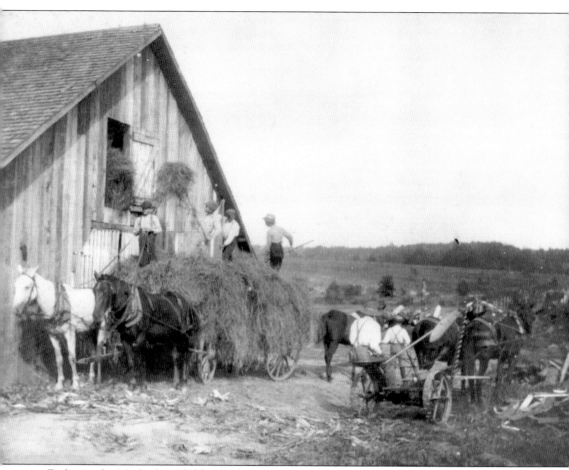

Early on, the Methodist Children's Home was a working farm. In its first year of operation, the Decatur farm produced five bales of cotton, 310 bushels of corn, 4,000 pounds of fodder, and 200 bushels of potatoes, peas, and other vegetables, according to Gerald Winkler's 2001 history of the orphanage. During its first year of existence, home superintendent Rev. R. W. Foote also oversaw the planting of 300 fruit trees. (Courtesy of United Methodist Children's Home.)

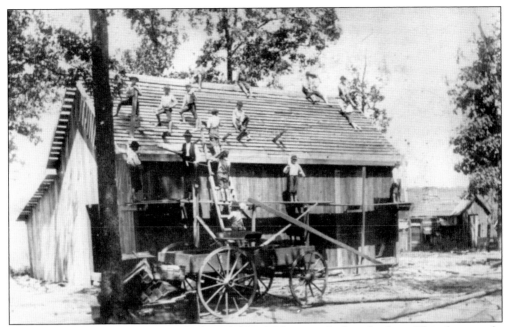

The children who lived at the Methodist Children's Home worked on the farm. This photograph, taken around 1900, shows boys building a blacksmith's shop. "Much of the boys' time was necessarily spent working on the farm, and the older boys also worked off campus on neighboring farms to earn a part of their livelihood," Gerald Winkler wrote in his history of the home. One resident later recalled, "if you were 12 or older and able to lift a hoe, you spent many hot afternoons plowing, planting, and cultivating." (Courtesy of United Methodist Children's Home.)

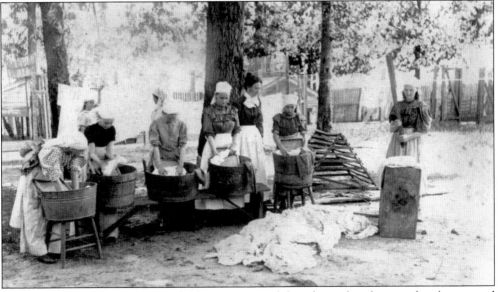

Girls from the United Methodist Children's Home wash laundry in this photograph, taken around 1900. One boy who lived at the home from 1936 until 1942 recalled later that the girls who did laundry had it rougher than the boys. "On hot summer days, with very little ventilation in the rooms, they had to endure the heat from a red-hot, pot-bellied stove," he recalled. (Courtesy of United Methodist Children's Home.)

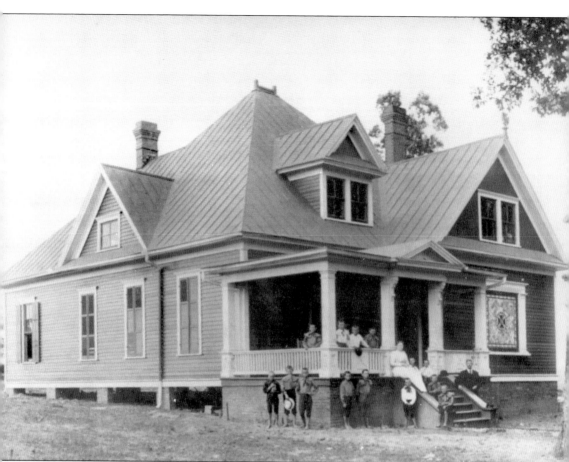

The first building to house children at the United Methodist Children's Home near Decatur was the two-story farm house that stood on the property when it was purchased for the facility. That house was modified to provide a dormitory for girls on one side and one for boys on the other. A kitchen and dining room were added on the back. As the children's home expanded in later years, the style of housing it provided changed. This photograph shows the Epworth League Cottage, which was dedicated in 1889. Like the original farm house, it no longer stands. (Courtesy of United Methodist Children's Home.)

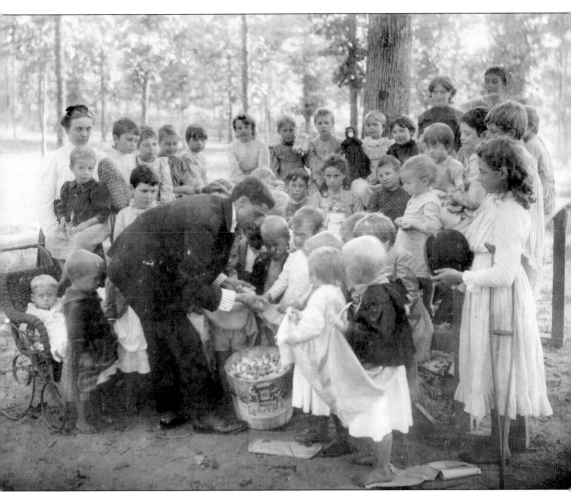

A benefactor of the United Methodist Children's Home, R. F. Shedden meets with children living at the orphanage. Shedden contributed to the construction of a cottage at the home, according to Gerald Winkler's history of the orphanage, and the building was named for him. But somehow, probably due to a typing error overlooked long ago, the cottage became the "Sheddon" Cottage, Winkler reported. (Courtesy of United Methodist Children's Home.)

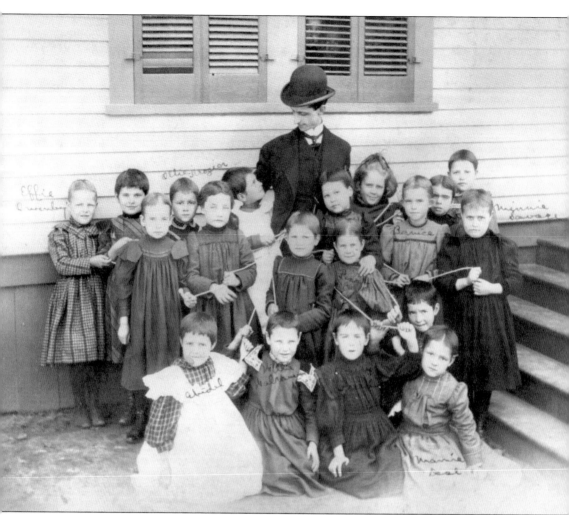

United Methodist Children's Home benefactor R. F. Shedden prepares for an outing with a group of girls from the home in about 1912. The children were tied together so they wouldn't get separated and lost. "We had plenty of time for recreation," former resident Bob Bell recalled in Gerald Winkler's history. "The movie house would let us in for free in groups of 10 or fewer." (Courtesy of United Methodist Children's Home.)

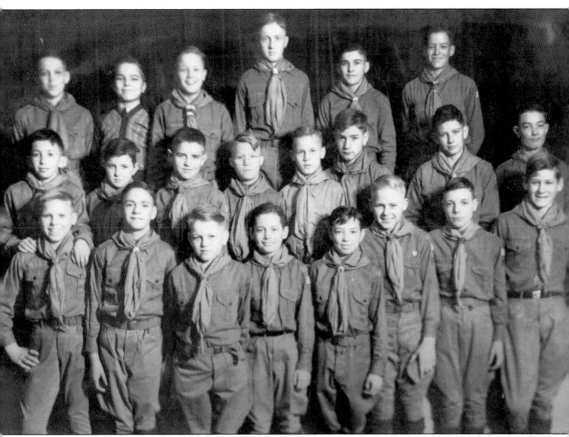

Boy Scout troops have long been active in Decatur. These scouts are members of the troop based at the United Methodist Children's home. Scouts and the Girl Reserves held jobs at the orphanage. During World War II, the children home's scouts served as air raid wardens. Should there have been an air attack, it would have been their job to get the younger children to shelter. Bob Bell, who lived at the home from 1938 to 1942, later recalled that children were constantly warned about possible enemy attacks. "My job during air raids (which, or course, we never had) was to stay at the campus bell and ring it if I sighted enemy aircraft." (Courtesy of United Methodist Children's Home.)

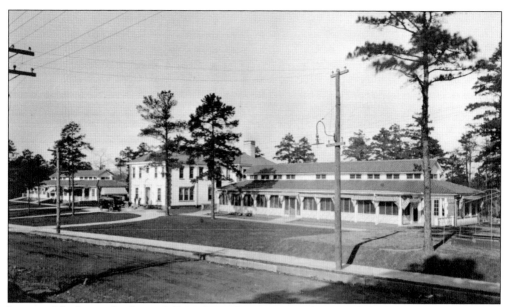

In rented facilities, the Scottish Rite Convalescent Home for Crippled Children was opened in 1915. The convalescent home offered 18 beds and a place for poor children to recover after surgery at other hospitals. In 1919, it was renamed the Scottish Rite Hospital for Crippled Children, and the institution opened a 50-bed orthopedic surgical hospital for poor children in what is now the Oakhurst section of Decatur. Atlanta architects Neel Reid and Hal Hentz designed the building. (Courtesy of Georgia State Archives, Vanishing Georgia Collection.)

Forrest Adair, an Atlanta developer and Fulton County Commissioner, was one of the founders of the Scottish Rite Hospital. He is shown here with a child at the hospital around 1915. Adair promoted the hospital and raised money from his fellow Scottish Rite Masons to build and operate it. Later he helped convince Masons from across the country to finance a national network of children's hospitals. (Courtesy of Georgia State Archives, Vanishing Georgia Collection.)

The idea for the Scottish Rite Convalescent Home arose after Dr. Michael Hoke treated a college student for a bone infection. The student's aunt, Mrs. William C. Wardlaw, was a friend of Dr. Hoke's. She asked how to repay him for his treatment of her nephew, and he asked if she would help raise funds for a facility to treat poor crippled children. Hoke became the institution's first medical director. (Courtesy of Georgia State Archives, Vanishing Georgia Collection.)

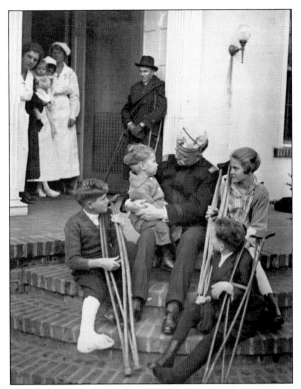

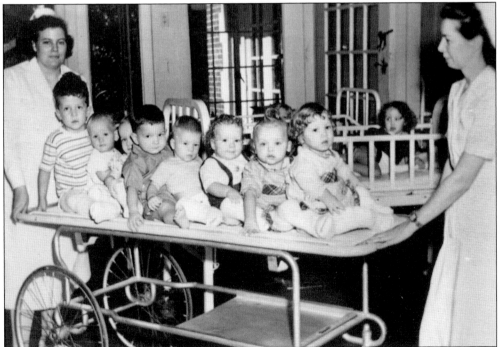

Nurses tend to a group of their small patients at the Scottish Rite Children's Hospital. The second medical director, Dr. Hiram Kite, perfected a nonsurgical treatment for clubfoot. (Courtesy of Children's Hospital of Atlanta.)

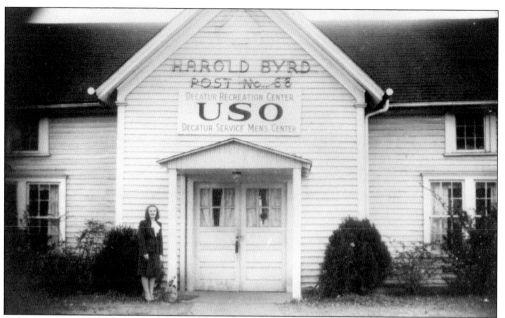

During World War II, the Harold Byrd Post of the American Legion hosted a branch of the USO (United Service Organization), which was a group that provided places where American servicemen could go to relax. The post was named for a soldier from metro Atlanta who served with the 327th infantry and died from wounds received from an artillery shell in the Argonne Forest during World War I. The post operated in Decatur before moving to facilities on Covington Highway in 1944. In the photograph below, the USO is providing a birthday party for servicemen visiting the Decatur Recreation Center USO. At left, Mrs. A. B. Lee pours tea.

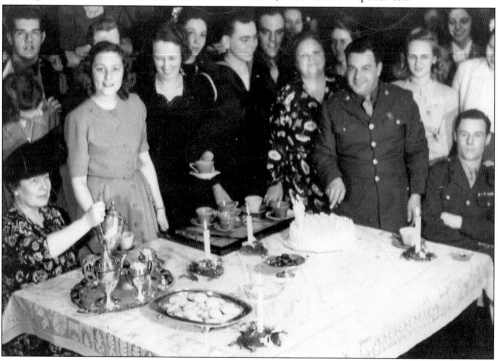

Nine

CHANGE IS
GOING TO COME

In 1963, the Decatur public school district's "north building" caught fire. The blaze in the building that had housed Decatur Boys' High School could be seen from various points throughout the city. Two years later, the school system razed the south building, which had housed both the old Central Grammar School and Decatur Girls' High, so a new high school could be built on the site. Those changes were just the beginning.

Within a few years, DeKalb County moved its offices from the old courthouse building that sat proudly astride the square and settled into a new high-rise just down McDonough Street. Soon MARTA (Metropolitan Atlanta Rapid Transit Authority) moved in, tearing up the streets to build a new train station beneath the square. Shops fled for the malls.

Decatur's segregated public schools began to integrate. The first tentative steps came in 1965, but they apparently were not enough. In 1972, the courts ordered Decatur's schools to fully integrate. School officials received the order on a Friday afternoon with direction that it had to be implemented by the next Monday morning. That Monday, many students reported to different schools than the ones they had attended the week before. Decatur was on a new path.

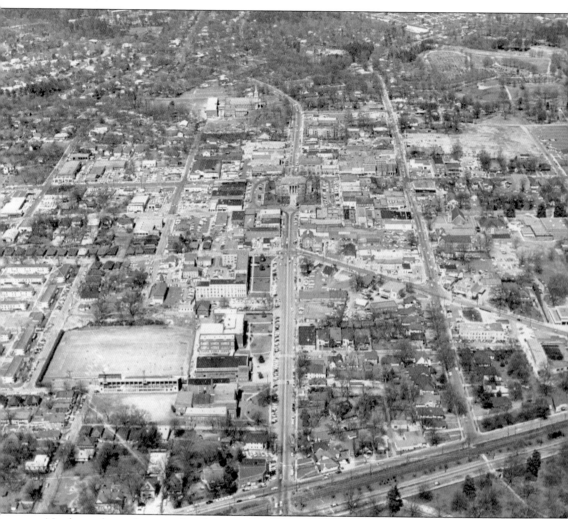

Not long after a photographer flew over Decatur and recorded this image of the city in the 1950s or early 1960s, a wave of construction began that would remake Decatur's downtown. The Central Grammar School building was razed to make room for a new high school. DeKalb County built a new high-rise courthouse building. MARTA built a mass-transit rail station beneath the courthouse square. The streets around downtown were reconfigured. Walkways and parking areas replaced streets where electric streetcars, farmers' pickups, and marching bands once had paraded.

BIBLIOGRAPHY

Clarke, Caroline McKinney. *The Story of Decatur, 1823–1899*. Fernandina Beach, FL: Wolfe Publishing Company, 1973.

Fox, Mary Walter. *The Sesquicentennial Celebration 1823–1973*. Decatur, GA: First United Methodist Church, 1973.

Gay, Mary A. H., *Life in Dixie During the War*. 5th ed. Decatur, GA: DeKalb Historical Society, Inc., 1979.

Jewett, Mary Gregory. *The First Fifty Years: A History of the First Christian Church of Decatur, Georgia*. Decatur, GA: First Christian Church.

Johnson, Hettie Pittman. *The Church Expanding, The Story of the First Baptist Church, 1862–1987*. Decatur, GA: First Baptist Church, 1957.

Price, Vivian. *The History of DeKalb County, Georgia, 1822–1900*. Fernandina Beach, FL: Wolfe Publishing Company, 1997.

Winkler, Gerald. *Home Life a History: The United Methodist Children's Home of the North Georgia Conference*. Milledgeville, GA: Boyd Publishing Company, 2001.

Wright, Alverta. *Not Here By Chance, The story of Oakhurst Baptist Church, Decatur, Georgia, 1913–1988*. Decatur, GA: Oakhurst Baptist Church, 1988.

www.decaturga.com

DISCOVER THOUSANDS OF LOCAL HISTORY BOOKS FEATURING MILLIONS OF VINTAGE IMAGES

Arcadia Publishing, the leading local history publisher in the United States, is committed to making history accessible and meaningful through publishing books that celebrate and preserve the heritage of America's people and places.

Find more books like this at
www.arcadiapublishing.com

Search for your hometown history, your old stomping grounds, and even your favorite sports team.